EAST KILBRIDE

THROUGH TIME

Bill Niven

AMBERLEY PUBLISHING

Acknowledgements

I am much indebted to John Ferguson of Queen's Park Camera Club for his expertise and professionalism in providing the modern colour images used in this volume.

Over a period of more than forty years the *East Kilbride News* has been instrumental in publishing several hundred of my articles on local history. Their support and encouragement have been most welcome.

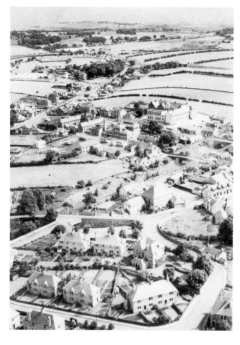

The village on Wednesday 9 July 1947 immediately before the establishment of East Kilbride New Town on Friday 8 August 1947.

First published 2009

Amberley Publishing Plc
Cirencester Road, Chalford,
Stroud, Gloucestershire, GL6 8PE

www.amberley-books.com

Copyright © Bill Niven, 2009

The right of Bill Niven to be identified as the
Author of this work has been asserted in accordance
with the Copyrights, Designs and Patents Act 1988.

ISBN 978 1 84868 678 6

British Library Cataloguing in Publication Data.
A catalogue record for this book is available from
the British Library.

Typeset in 9.5pt on 12pt Celeste.
Typesetting by Amberley Publishing.
Printed in the UK.

Introduction

In the Beginning

Saint Bride was born near Kildare in Ireland around AD 453. Over the centuries many churches and holy places have been dedicated to her and our town of East Kilbride bears her name. The Gaelic prefix *cill*, a church, provides the prefix for the name Kilbride which simply means – the Church of Bride.

We have no precise date for the foundation of the Church of Kilbride. In a court case involving John Parson of Kilbride it was stated that 'a church had existed from a very ancient time'. The foundations of our church were laid at least one thousand years ago. The peoples of Scotland in the Dark Ages left little in the way of recorded history.

The Middle Ages

Kilbride did not assume the prefix East until 1800. In the Middle Ages, Kilbride was a small, insignificant huddle of houses eight miles south of Glasgow, with a population around the 200 mark. Apart from the Church of Kilbride there was no building of note. The mediaeval church was a small stone oblong building with an earthen floor. There were no windows in the village houses and a turf fire burned on the earthen floor.

The village supported a few tradesmen, a couple of booths selling food and an inn. Farming was almost the sole occupation for the 1,000 people who lived in the village and its wider parish of 23,000 acres.

The Reformation of 1560 saw Scotland adopt the Protestant faith in lieu of Catholicism. The eighteenth century saw the birth of East Kilbride's most famous sons – the brothers William Hunter (1718–1783) and John Hunter (1728–1793). William was the most eminent obstetrician of his day and delivered all Queen Charlotte's fifteen children. John Hunter was an anatomist of European celebrity and is considered to be the father of modern scientific surgery. The advent of handloom weaving around 1750 brought prosperity to the village and the new turnpike or toll roads of 1791 brought ease of communication, which in turn was the cause of economic growth.

The Caledonian Railway

When the railway line was opened in 1868 village life was transformed. Glasgow was less than an hour away and for the first time it was

possible to live in East Kilbride and work in Glasgow. The railway provided the only reliable link with the outside world until the first regular bus services commenced in the early 1920s.

The public services were transformed during the late nineteenth century with the introduction of gravitation water and sewage purification.

The advent of the railway fostered a considerable building boom in the village in the shape of villas and semi-villas, followed sixty years later by the construction of 200 local authority houses. Despite the expansion, East Kilbride was a pleasant and friendly place where life went by at jog trot pace. At the end of the Second World War the population was 2,500.

East Kilbride New Town

The rapid growth of Glasgow during and after the Industrial Revolution produced highly unsatisfactory and crowded living conditions for many inhabitants. East Kilbride was chosen under the New Town Act to be the first of Scotland's five New Towns. On 8 August 1947 the East Kilbride Development Corporation was established with an area of 6,000 acres and a final target population of 70,000. The Corporation was to continue until 31 December 1995. Torrance House was purchased as the corporate headquarters. Progress was slow in the early years due to the post-war shortages of building materials. The first 68 houses were completed in the summer of 1949. By the end of its life the Corporation had built 23,600 homes.

In economic terms the New Town was exceptionally successful. In the early years Rolls-Royce were attracted to the town and the Government's National Engineering Laboratory was established there in the early 1950s. Other major public bodies who set up in the New Town were the Inland Revenue Centre 1 and the Department for Overseas Development. The momentum of industrial growth was maintained in the private sector and Motorola became the largest employer. By its closure in 1995, the Development Corporation had created 35,000 jobs and was considered to have established a benchmark for urban regeneration.

The New Town was well served throughout the period by the Burgh of East Kilbride and its successors. The community enjoys a wide range of leisure activities. Covered shopping malls became an important feature and the success of East Kilbride can be judged from its accolade as Britain's most successful New Town, given by the Town and Country Planning Association.

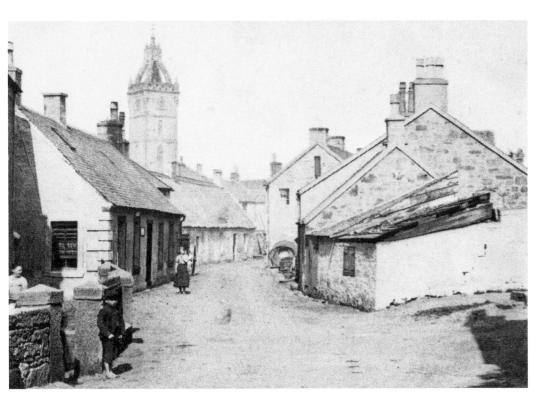

Glebe Street
The village of East Kilbride was founded in Glebe Street 1000 years ago. The 1895 image shows the post office on the left and the old parish church steeple in the distance. William Hunter, the famous gynaecologist, was born here in 1718.

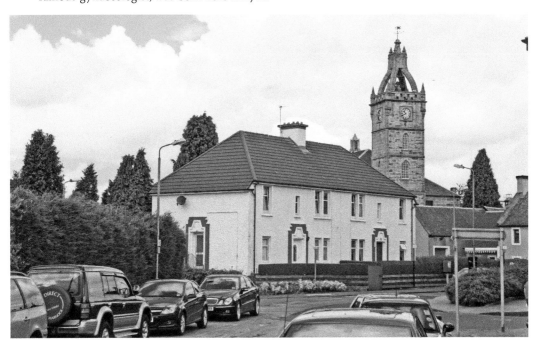

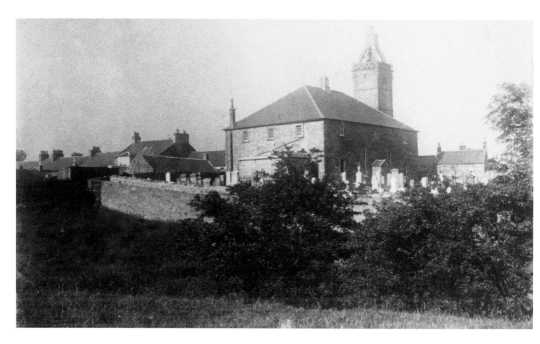

Old Parish Church

The building on display was constructed in 1774 and was one of a series of buildings constructed on this site over the centuries. Saint Bride (AD 453–525) was a disciple of St Patrick and gave her name to many religious institutions.

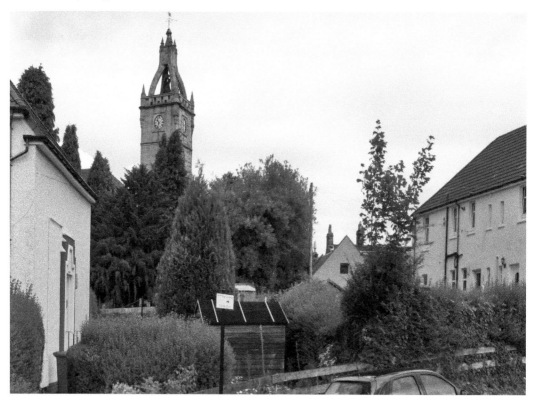

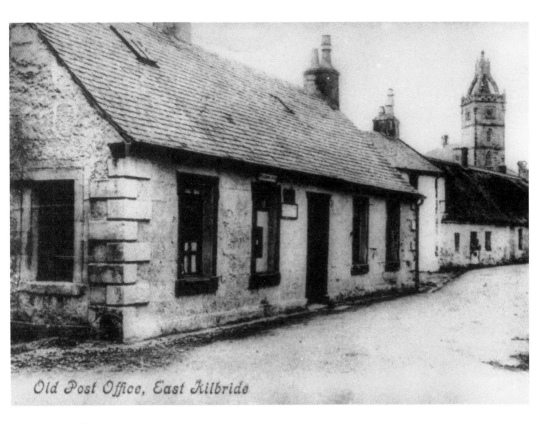

Old Post Office, East Kilbride

Post Office

This image, dated 1904, depicts the second village post office. All the old Glebe Street buildings have been replaced over the period for industrial, community and residential purposes. The word Glebe means 'belonging to the church'.

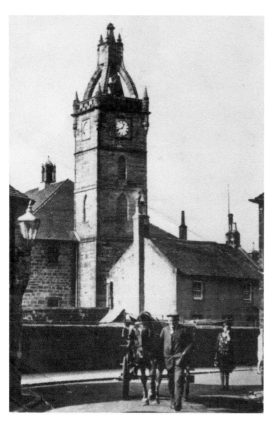

The Local Milkman

Jimmy Scott of Cantieslaw Farm was the local milkman. Milk production was the mainstay of East Kilbride farmers. The black and white building in the colour image was the village court house and jail until 1745.

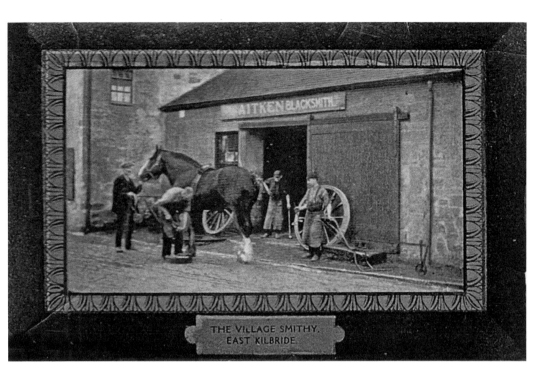

Aitken's Smithy

Aitken's Glebe Street Smithy in 1906. The village possessed two smithies – the other being Beggs in Parkhall Street. This modern image shows the emphasis placed on blending old and new architectural styles.

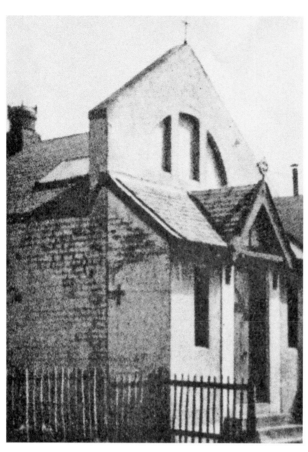

St Bride's Church
The Roman Catholic population worshipped in various temporary premises in Glebe Street until the building of St Bride's church in 1907. The faithful now worship in a modern building built on Whitemoss Avenue in 1964.

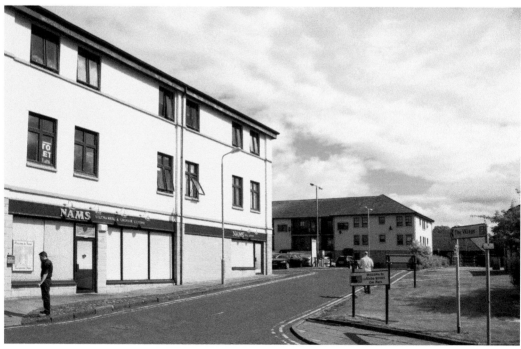

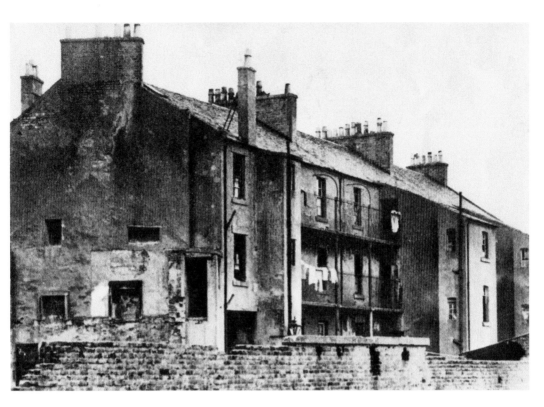

Kirklee

On the west side of Glebe Street, Kirklee was constructed by Ure the quarrymasters. In 1955 Kirklee was demolished and in 1970 the new halls of the old parish church were opened.

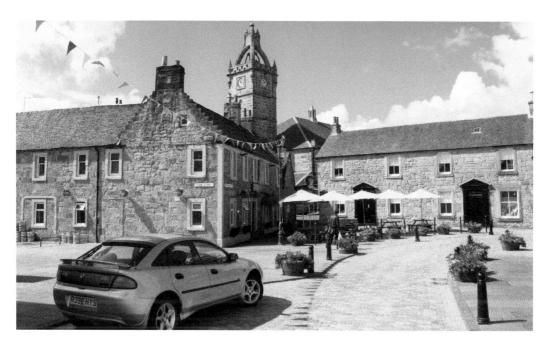

Village Centre

The village of East Kilbride grew up around Glebe Street and the parish church. On the far left is the post office and adjacent is the gable end of the Auldhouse Tavern. Next again is the Montgomerie Arms opened in 1719.

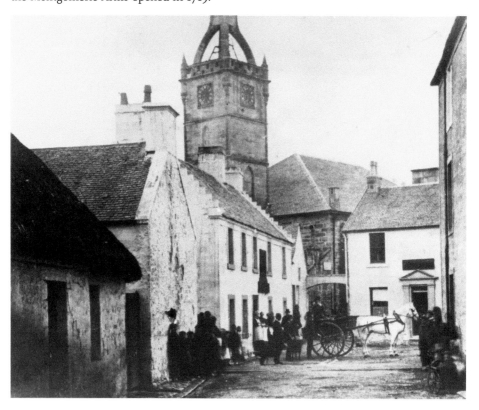

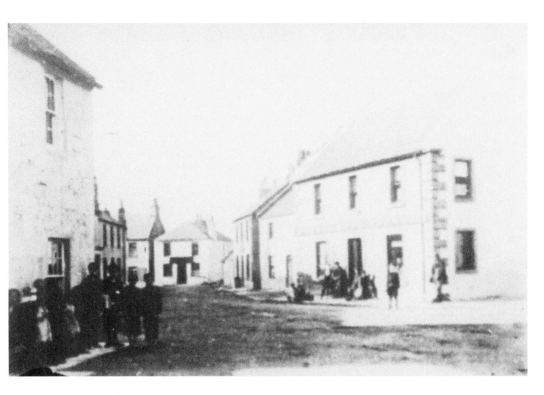

Montgomery Street

Montgomery Street was the oldest thoroughfare and the most important for many centuries. Dragoons mustered here during Covenanting times. At the far end was the Railway Tavern which was demolished in the 1950s. A strong effort to preserve the old has been effective.

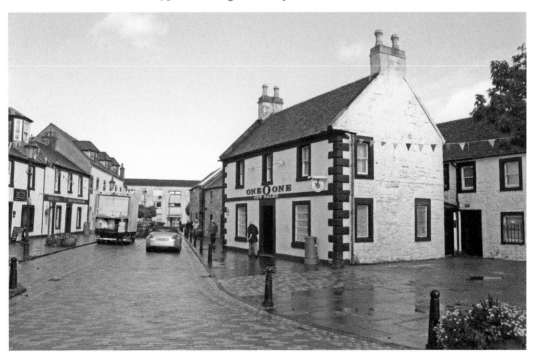

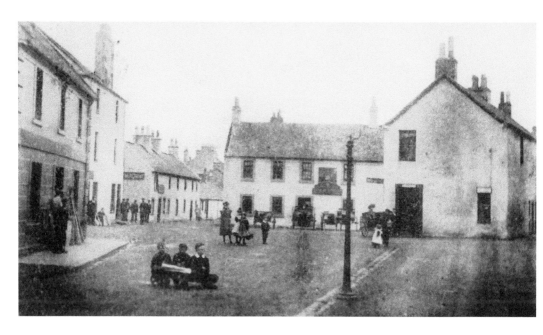

Busy Street Scene

Until 1791 East Kilbride had one street (now Glebe, Montgomery and Parkhall). In addition there were two lanes (Hunter and Kittoch). The 1904 panorama is a fine representation of village life before World War One.

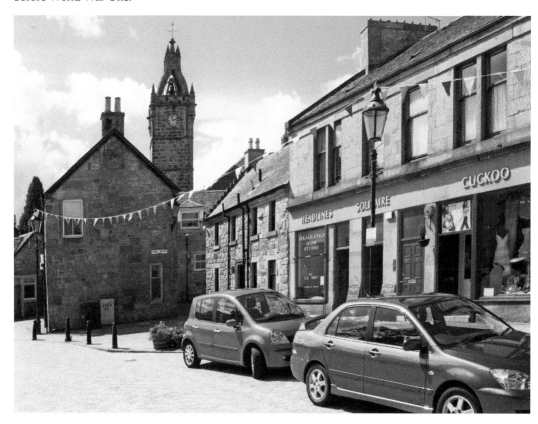

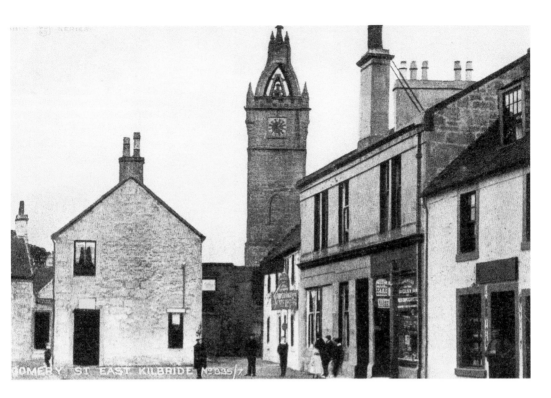

Strait Dykes

The strait or narrow dyke was the beginning of the old road south via Auldhouse and the English border. At the entrance was the Temperance Hotel – a reminder of the temperance movement which was a powerful social force until the 1920s.

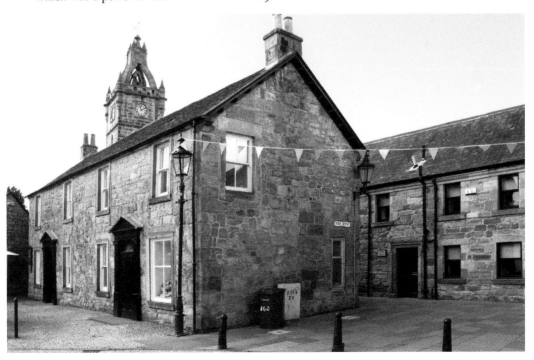

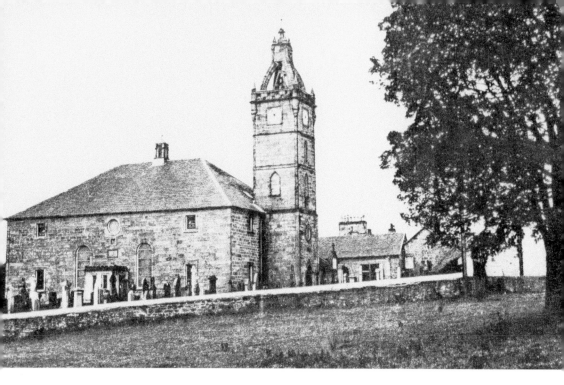

Scotch Crown Belfry

The graveyard which surrounds the church is circular, which may point to its use for sun worship in pre-Christian times. The church was built to the side walls at a cost of £570 in 1774. The steeple was added in 1818 with its Scotch Crown Belfry.

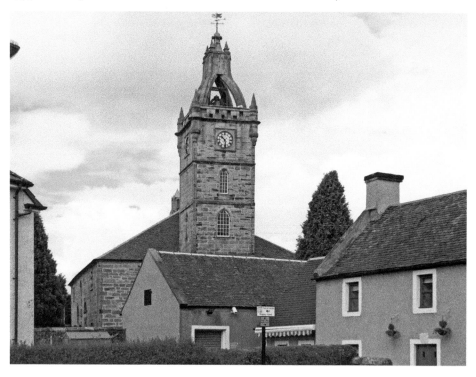

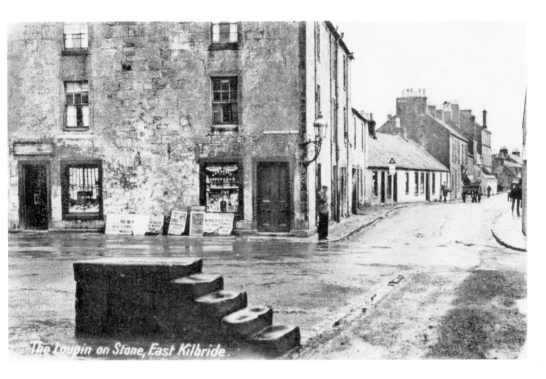

Loupin on Stone

The Loupin on Stone in Montgomery Street dates from 1719 and was used by riders for mounting and dismounting. The large tenement on the left is the Big Land and is now replaced by Legends Bar and Restaurant.

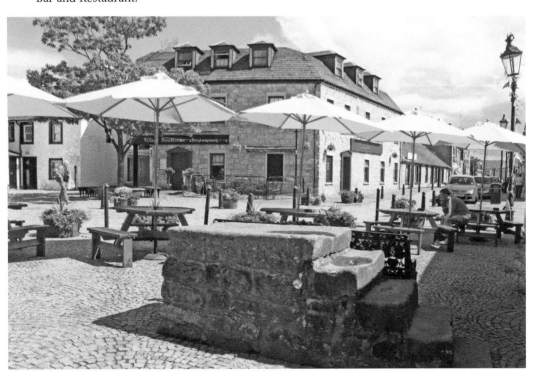

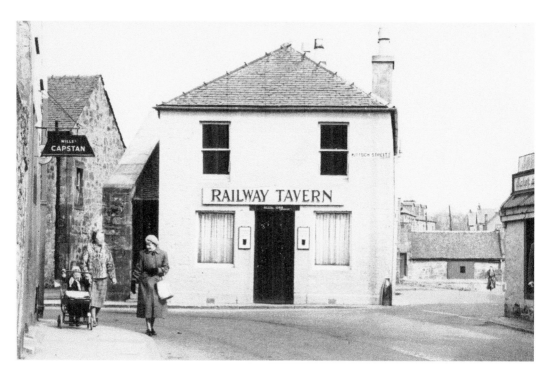

Railway Tavern

The Railway Tavern at the top of Montgomery Street was built in 1871 and demolished in 1959. Begg's Smithy, sat on the corner of Parkhall and Kittoch Street, can be observed on the right of the Tavern.

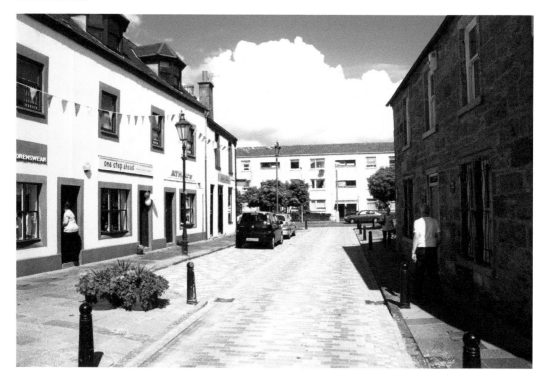

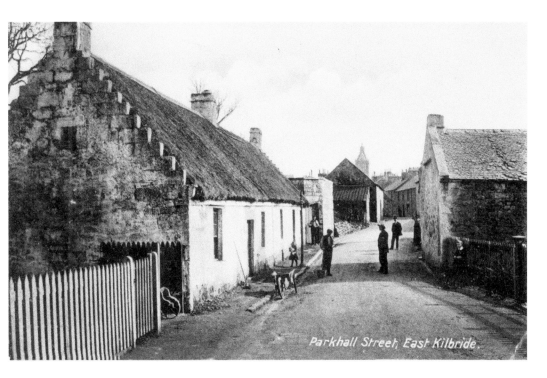

Parkhall Street

The earlier photograph of the south portion of Kittoch Street depicts an old tavern on the left and the smithy on the right. The modern image, facing north, shows the new flats with a car park beyond.

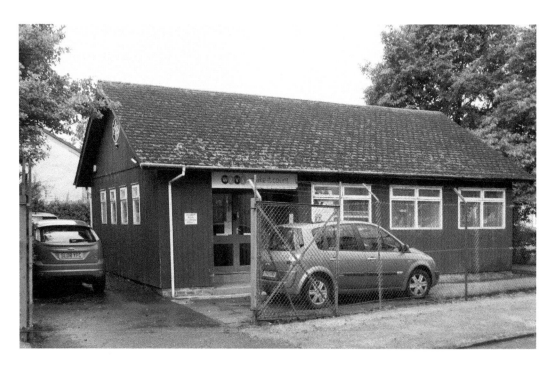

Begg's Smithy

The modern image depicts the WRVS headquarters in Parkhall Street. The older picture shows Begg's Smithy in 1959, immediately prior to demolition. The two smithies – Begg's and Aitken's – were integral to the prosperity of East Kilbride.

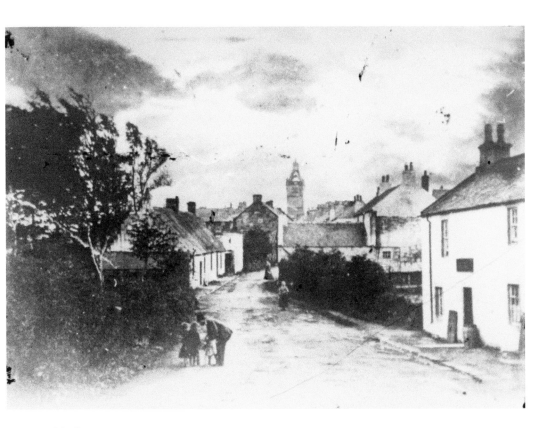

Parkhall Street

Until 1791 the sole link between Glasgow and East Kilbride was the Lang Causey. The Caledonian Railway reached the village in 1868. This is Parkhall Street in 1876. The grocer's shop on the near right was demolished when the railway line was extended.

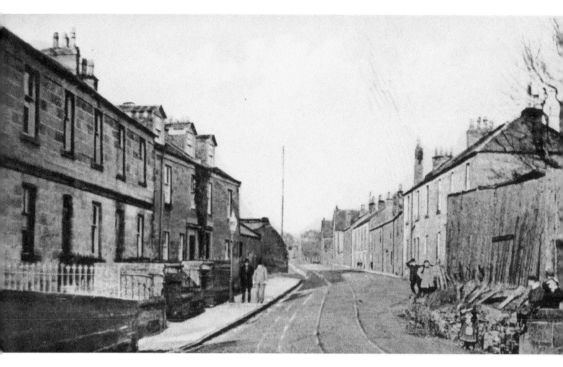

School Lane

Parkhall Street was the most northerly section of the village's ancient road system. School Lane lay between Parkhall and Main Street. This modern extension has been placed on the opposite side of Parkhall Street.

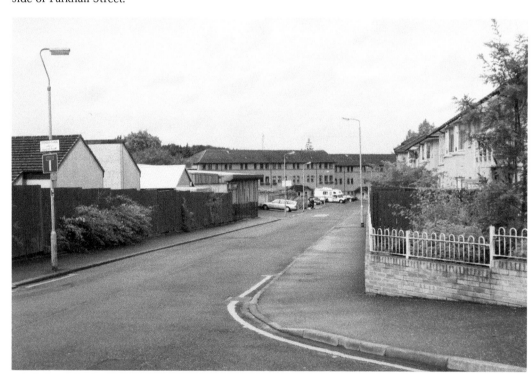

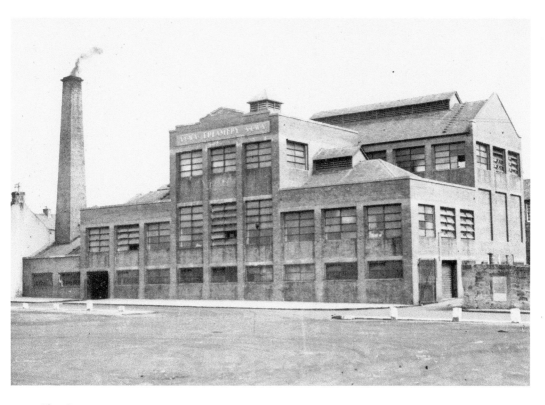

The Creamery

Parkhall Creamery was built by John Baird in around 1875 and was extended to Parkhall Street in 1933 by the Scottish Co-operative Wholesale Society who had purchased the business in 1918. At its peak, eighty employees were on the payroll.

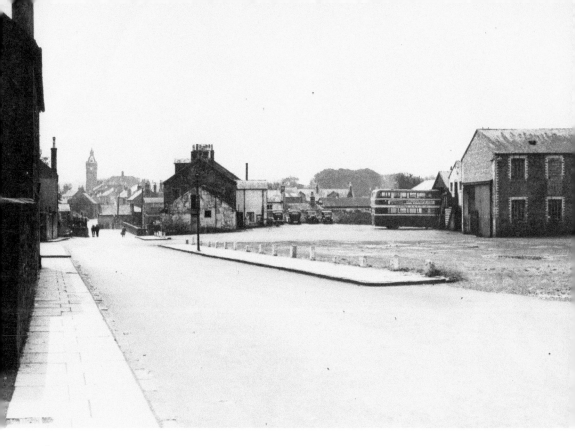

The Bus Garage

A Rankin Brothers' regular bus service to Glasgow was inaugurated in 1923. Eventually the business was bought by the Central SMT who constructed this depot in Parkhall Street. The site is now largely residential.

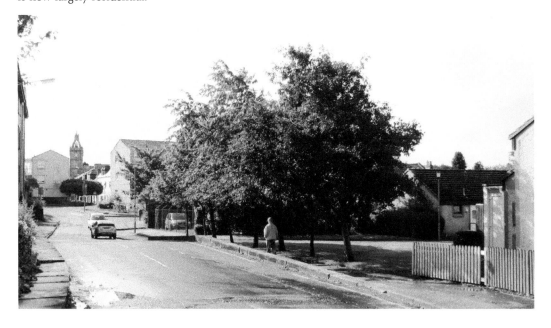

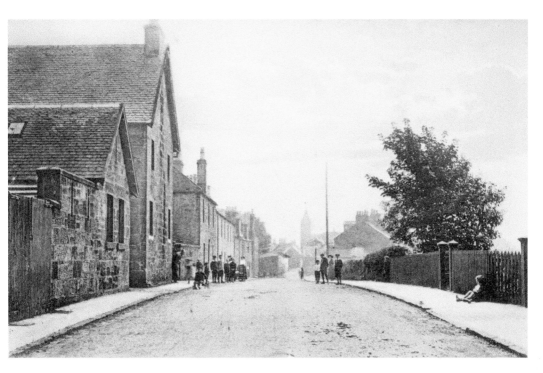

Torrance Square, 1918

Beyond the group of people on the left is the original Baird's Creamery. The SMT bus garage on the right of the image lay in this spot for many years. The modern view shows the two wings of the Torrance Hotel, reconstructed in 1965.

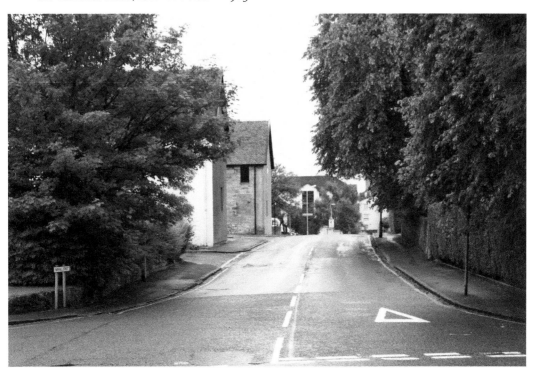

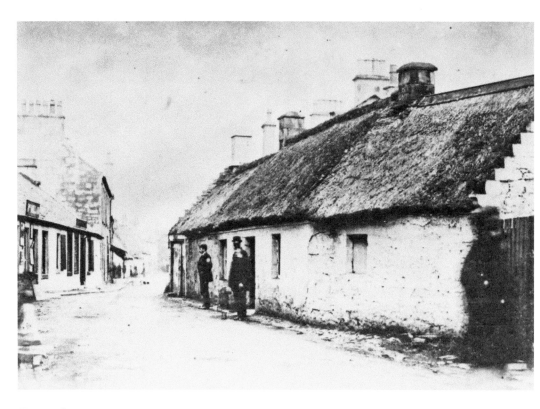

Hunter Street

Hunter Street was originally a lane leading from Montgomery Street, giving access to Maxwellton village. The street takes its name from the Hunter brothers – doctors and anatomists who became East Kilbride's most eminent sons.

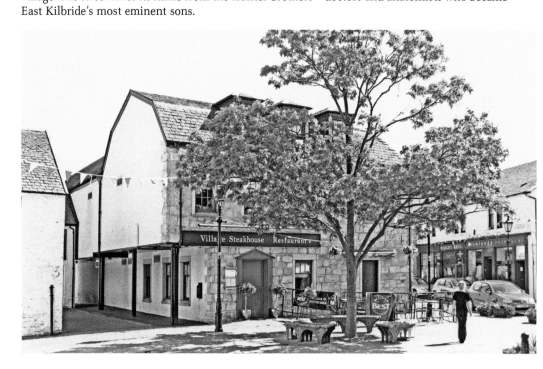

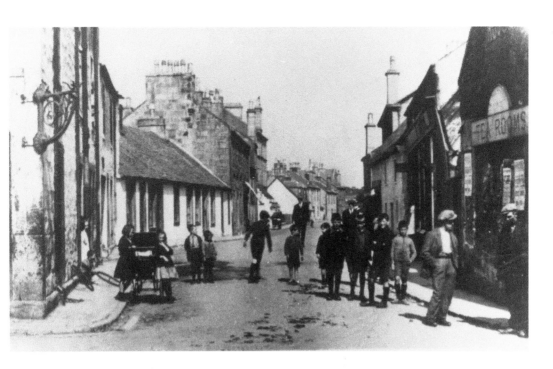

Busy Village

A summer scene in Hunter Street in 1928. The building on the left is the Big Land where the absence of a gas globe indicates summer nights. The one-storey cottages on the left were typical weavers' dwellings.

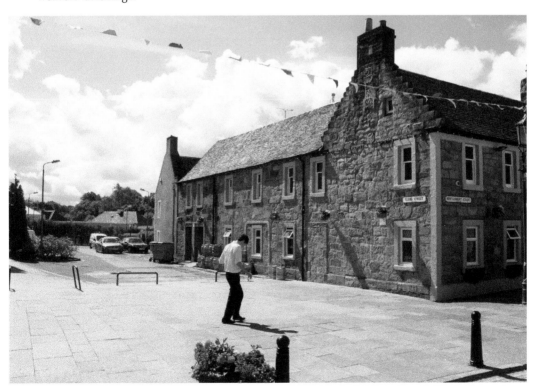

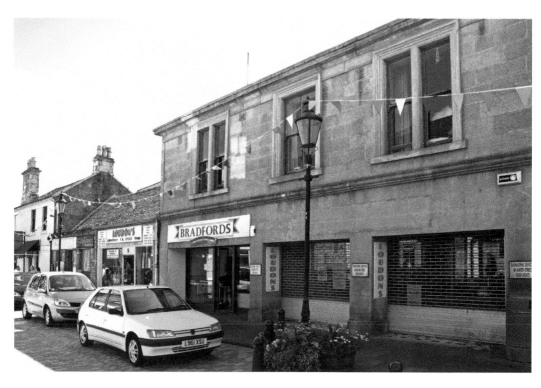

The Hearse

The bright orderly shops of modern-day Hunter Street. The older image, taken in 1910, looks west towards Montgomery Street and the parish church, where a hearse, drawn by black horses, can be observed.

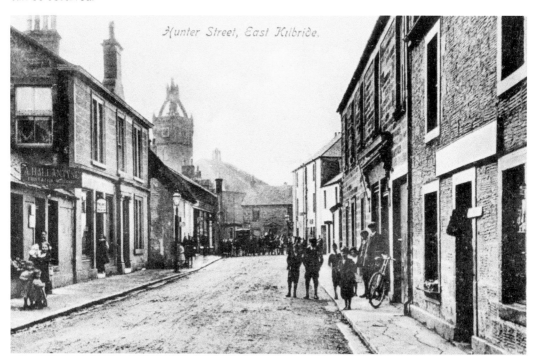

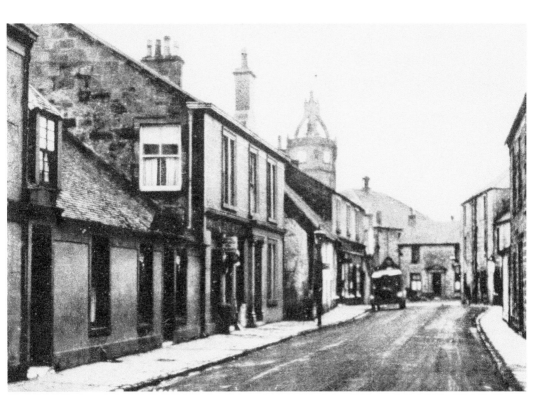

Last Thatched Building

This photograph is of Hunter Street in the winter of 1918. The whole building immediately beyond the lamp post (centre left) is the last thatched building extant in East Kilbride. The modern image provides a good example of a sympathetic restoration.

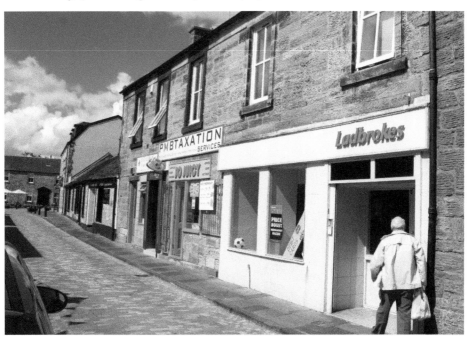

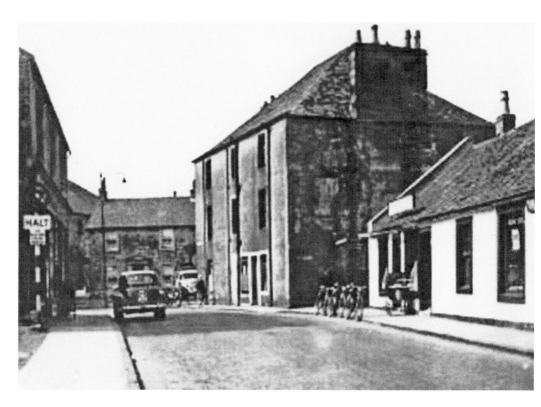

The Weavers

The handloom weavers prospered from 1780 until 1850. East Kilbride gave employment to sixty-five weavers who worked from their homes. The two views, old and new, provide a good example of the weavers' villages.

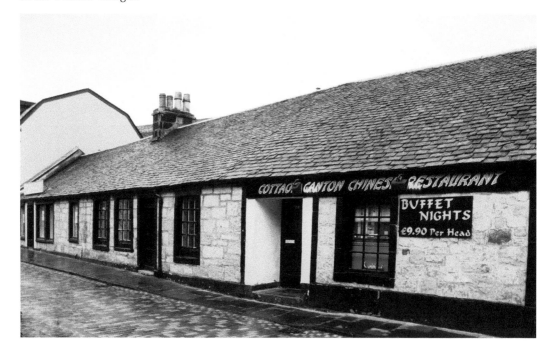

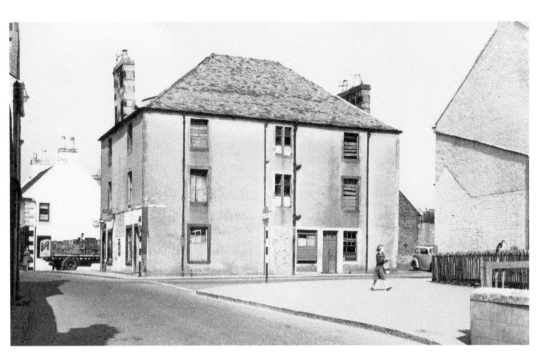

The Big Land

This tenemental building was situated on the corner of Hunter and Montgomery Street. Apart from flats, the building contained retail shops and a bookmaker. Legends Bar and Restaurant now occupy the site.

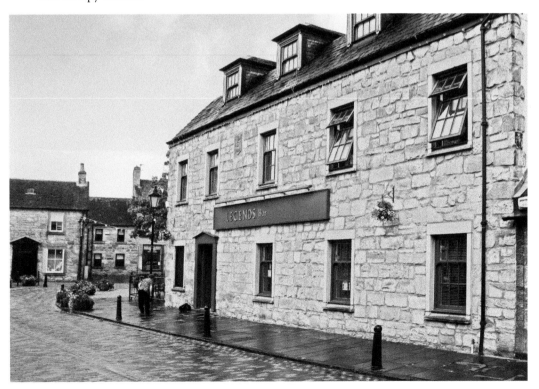

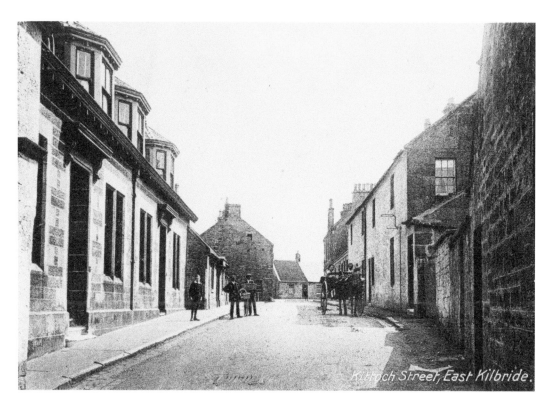

Kittoch Street

This street was one of the original lanes in East Kilbride and connected the town to the west. This view from 1914 shows the top of Meeting House Brae which led down to the West Kirk. The right hand buildings have been largely replaced.

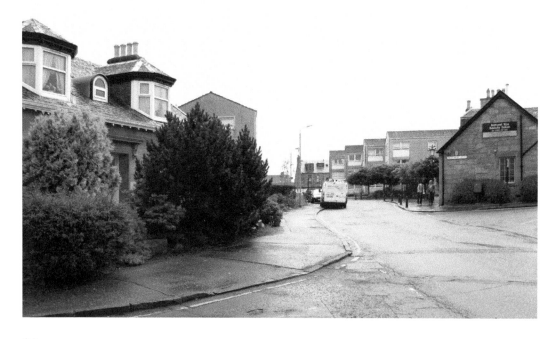

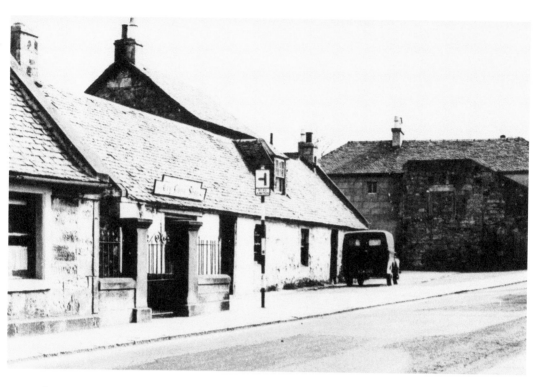

The Curio Shop

This Kittoch Street image of 1954 shows the Masonic Lodge gates in the rear left, then the Curio Shop and, on the right, the bulk of the Railway Tavern. These buildings have been demolished and flats now take their place.

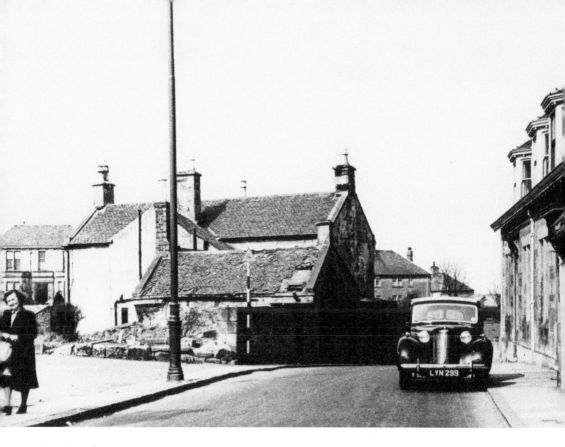

Ann's Lodge

The large building on the left is Ann's Lodge (demolished 1954). The block of new flats in the centre of the modern picture has replaced the West Kirk manse.

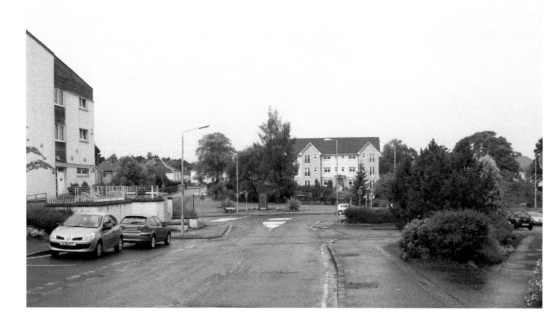

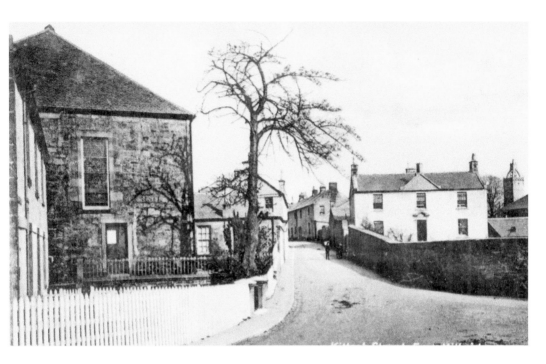

West End

The west end of Old East Kilbride consisted of the West Kirk and Ann's Lodge until the advent of the Kirktonholme Housing Scheme in 1923. The modern picture depicts Lindsay House, managed by South Lanarkshire Council.

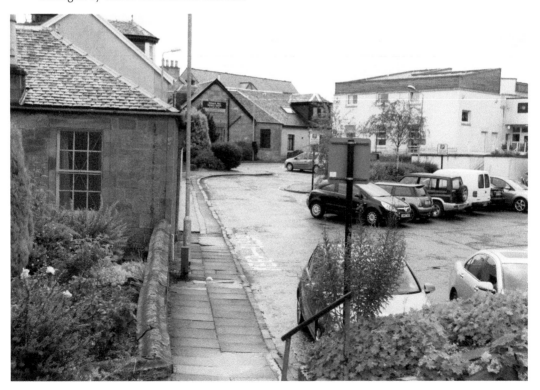

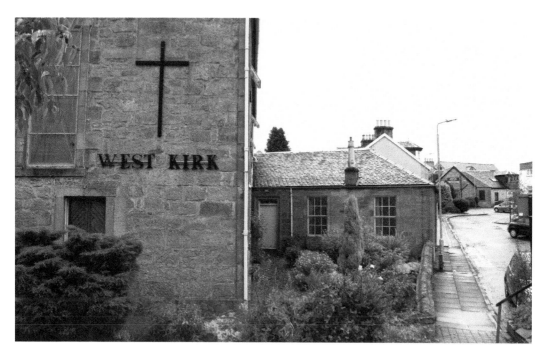

The West Kirk

Founded in 1791 as a relief church, the West Kirk was a secession from the old parish church. The congregation prospered as a United Presbyterian and later a United Free Church before rejoining the Church of Scotland in 1929.

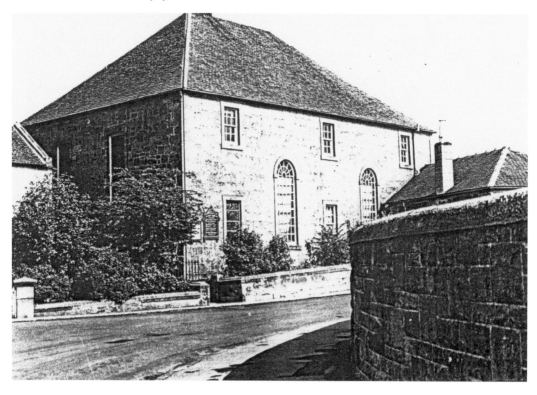

Markethill Road

The Lang Causey in Markethill Road was the original link to Glasgow over the centuries. The statue of Sir Walter Scott was erected in the grounds of Laigh Markethill Cottage in 1871 to celebrate the centenary of his birth.

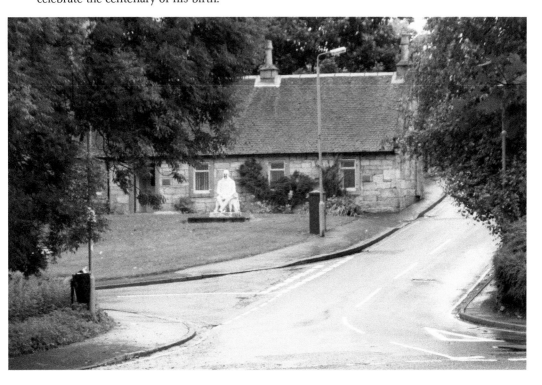

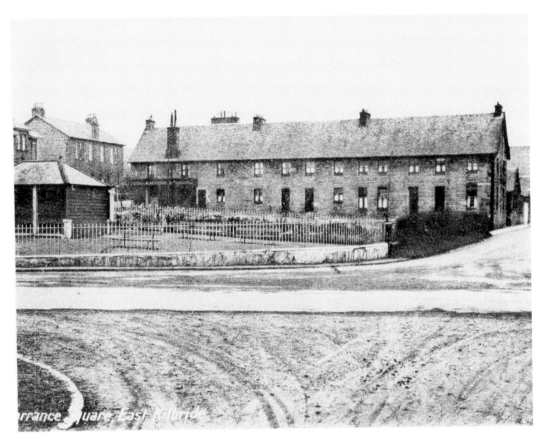

Torrance Square

The building was originally a cotton spinning mill from 1783 to 1792. After the turnpike road was completed, the east end became the Torrance Hotel and the remainder became dwelling houses. In 1965 the whole building was converted into a hotel.

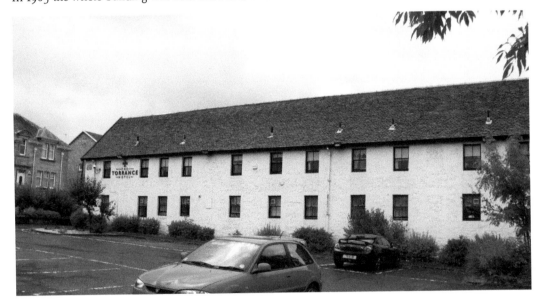

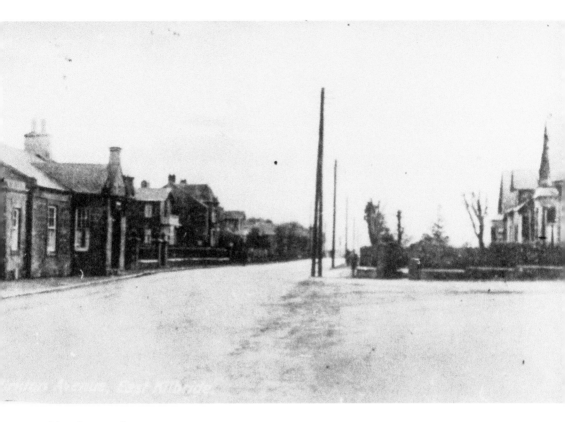

Old Police Station

The stone building on the left was the Big Toll, built to administer the turnpike road. From 1883 it became the village police station and in recent years it has been established as a dental surgery.

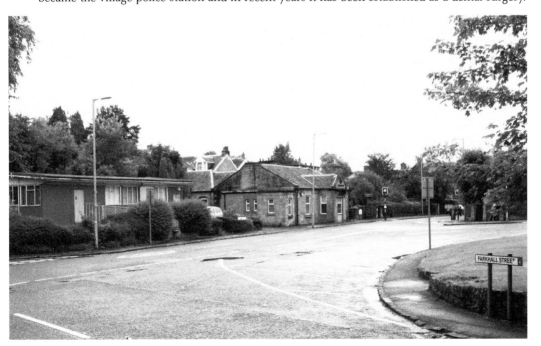

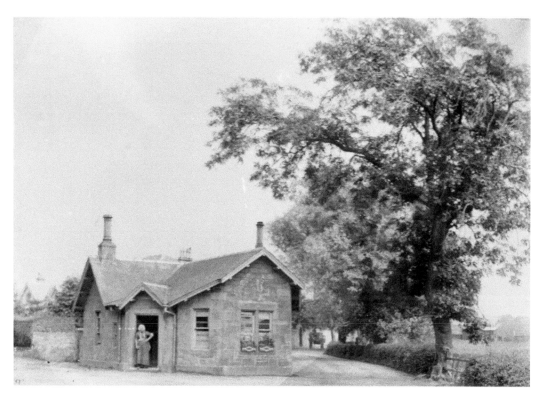

Wee Toll

A chiropodist and podiatrist currently occupy the Wee Toll. In the older image, Kittoch Street led into Eaglesham Road at its junction with Graham Avenue. The Wee Toll was built as a toll house for the Edinburgh to Ayr turnpike in 1791.

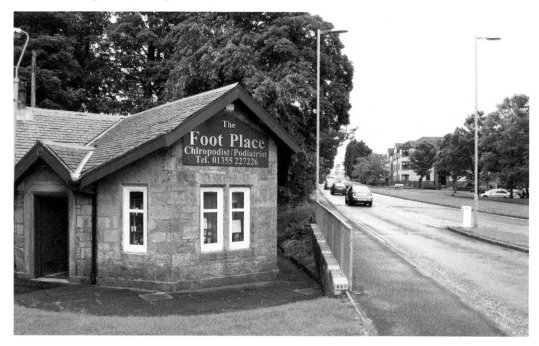

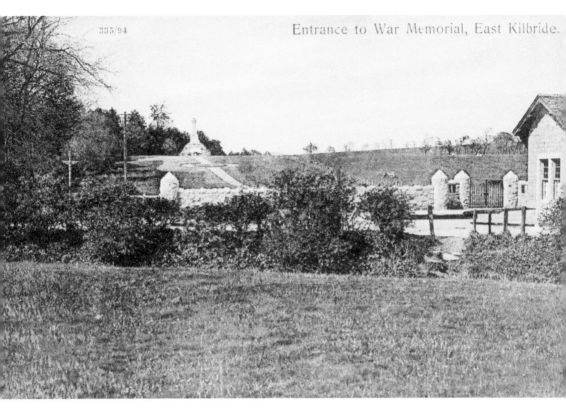

War Memorial

The war memorial in Graham Avenue was
unveiled in 1921. The obelisk stands as a
dignified monument in a secluded corner.
The names of the dead of the Second World
War were added in 1949. The early picture
shows the grounds before the planting of
trees and shrubs.

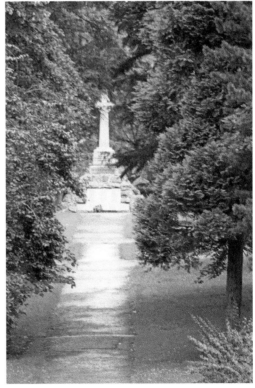

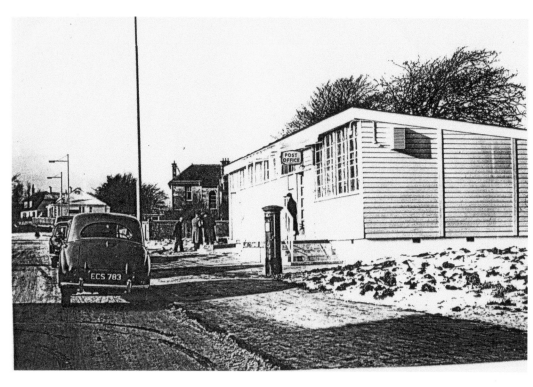

Town Centre Post Office

As the town centre was being developed in the late 1950s, a temporary post office was erected on adjacent ground. In the 1960s the local fire station was constructed on this site.

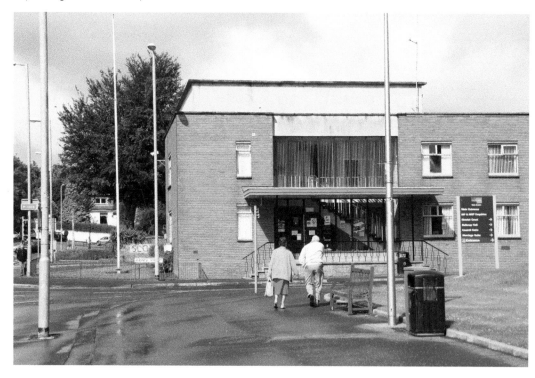

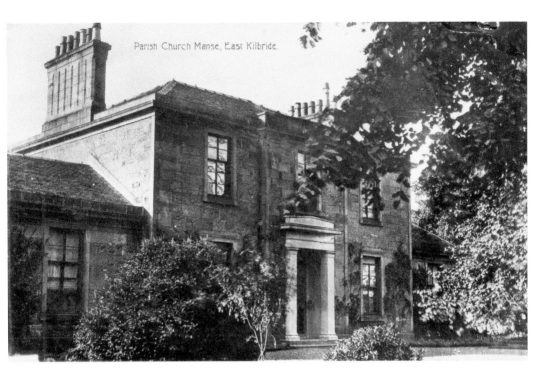

Church Manse

The old parish church Manse in Stewart Street was built in 1838 and was described by its first incumbent as '...an elegant modern building as well as a most comfortable habitation.' The building was sold for private housing in 1983.

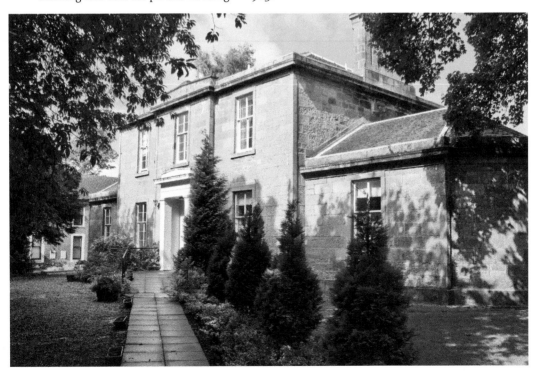

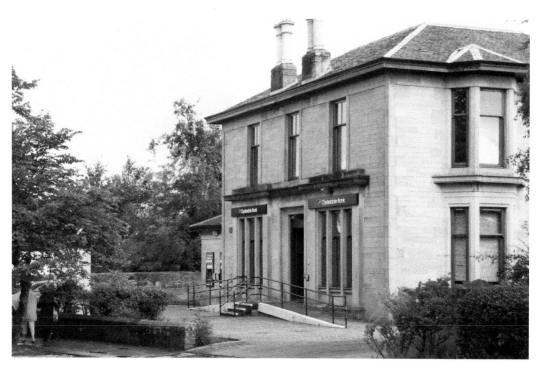

Clydesdale Bank

The Clydesdale Bank was built in Stuart Street in 1883, having been in Kittoch Street since 1878. East Kilbride's first bank was the National Security Savings Bank of Glasgow which opened as an agency from 1839 to 1846.

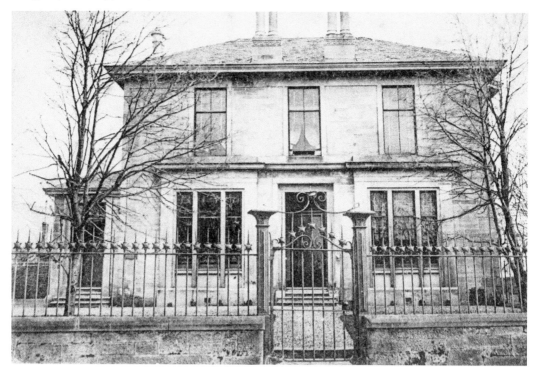

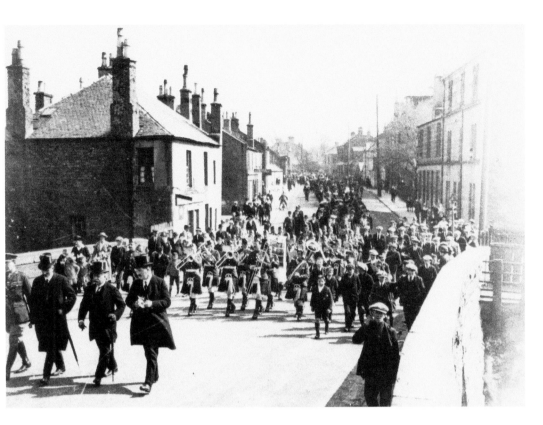

Procession

The date is 1 May 1921 and this procession is marching to the opening of the war memorial in Graham Avenue. In the foreground is the railway bridge where the Caledonian Railway ran to Blantyre. The bridge still remains in today's image but the railway was closed in September 1939.

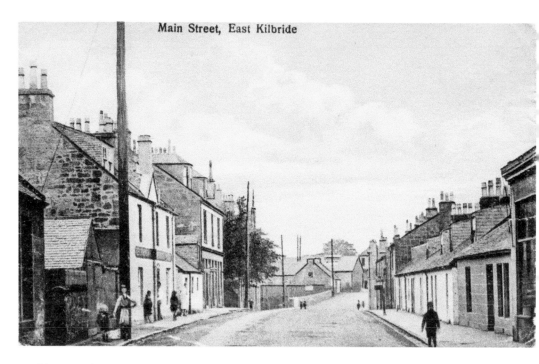

Main Street, East Kilbride

Looking North

This black and white picture depicts Main Street in 1918 looking north. Main Street came into being in 1791 with the building of the turnpike road from Glasgow to Strathaven. In the modern image is the Torrance Hotel, which was opened to serve the turnpike.

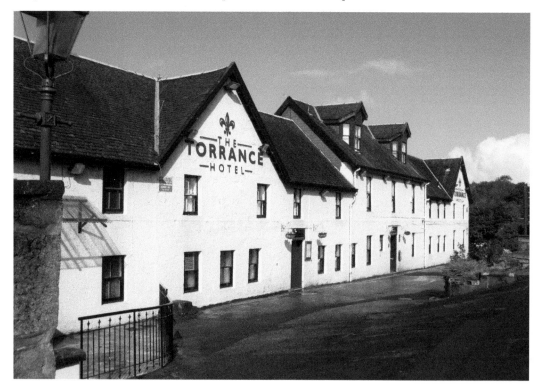

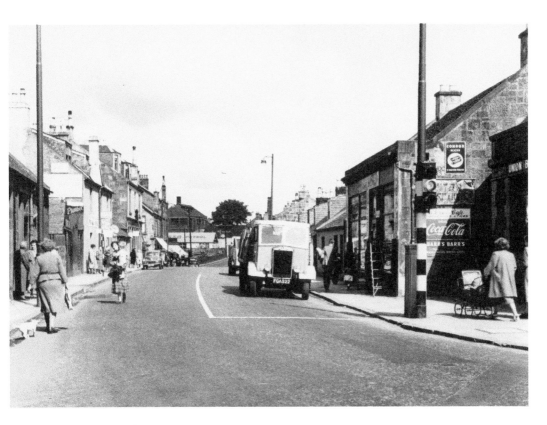

Village Crossroads

The older picture shows the Cross Roads in 1954 in the early days of the New Town. Main Street became the main thoroughfare of the village after 1791. The coloured image of 2009 shows the right side has altered, while the left side is largely recognisable.

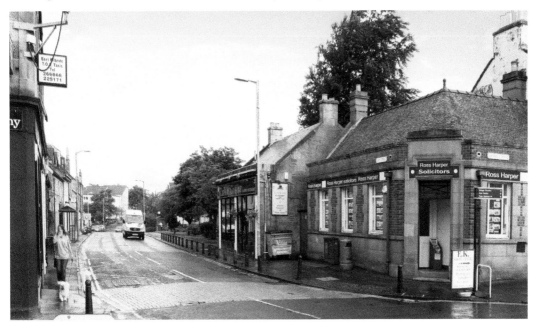

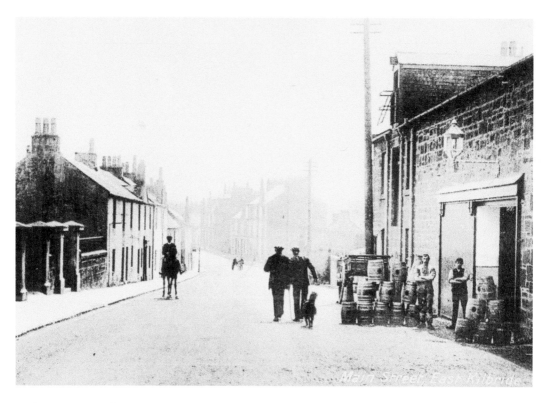

Main Street Housing

The New Town flats of the 1960s dominate the scene. They were part of the East Kilbride Development Corporation programme which built 23,500 dwellings between 1947 and 1995. The older image depicts the Creamery in 1914.

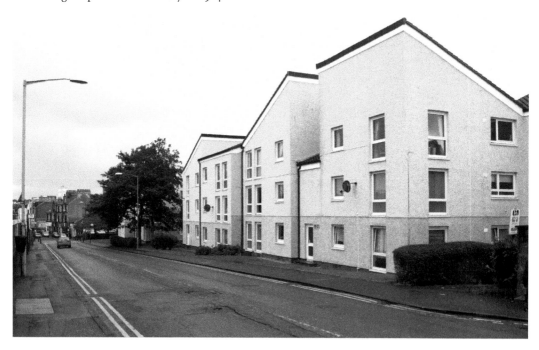

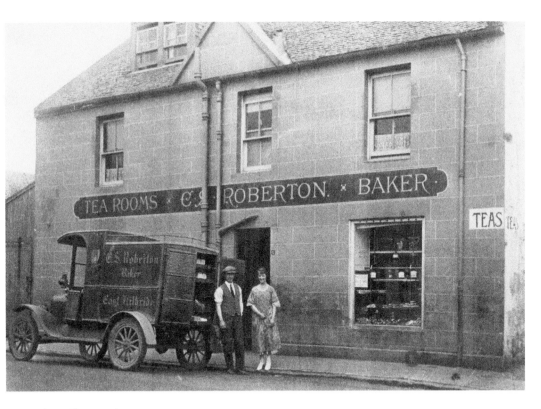

The Village Baker

Carswell Roberton was the village baker. Outside the Main Street shop are John and Bunty Roberton in the 1920s. Main Street is still a prosperous shopping district today.

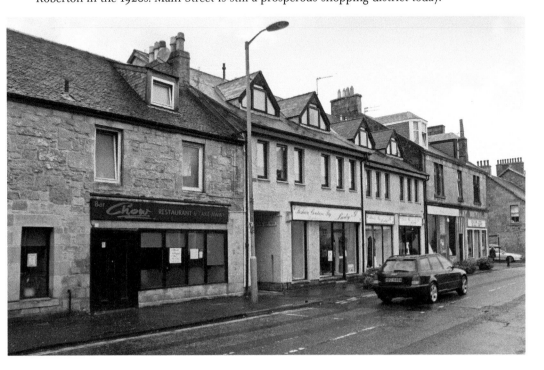

49

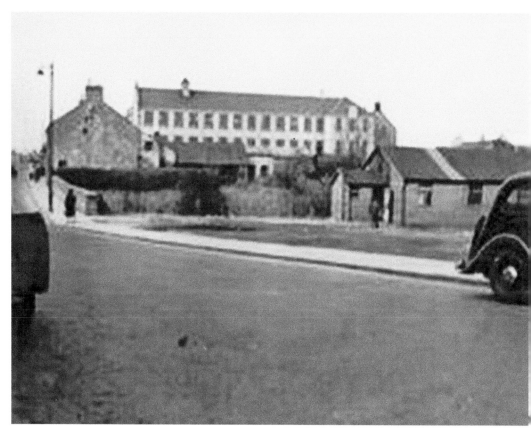

Village School

In 1844 the village school moved from the churchyard to Main Street. After 1974 it served as a community college. The buildings were demolished in 2008 and the image taken at the corner of Old Mill Road shows the new housing site.

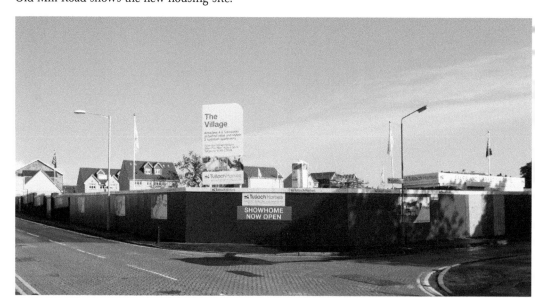

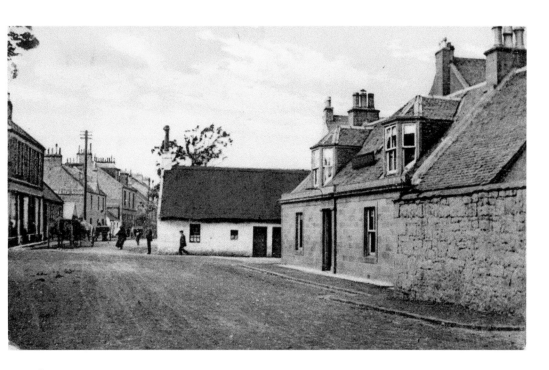

Fourways

The two images show the contrasting interchange of shops and houses at the village crossroads. In the older view of 1912 the Cross Roads Inn is on the far right and Kate Dalrymple's Cottage is centre stage.

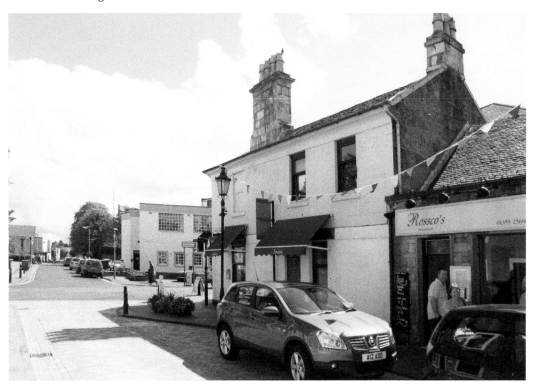

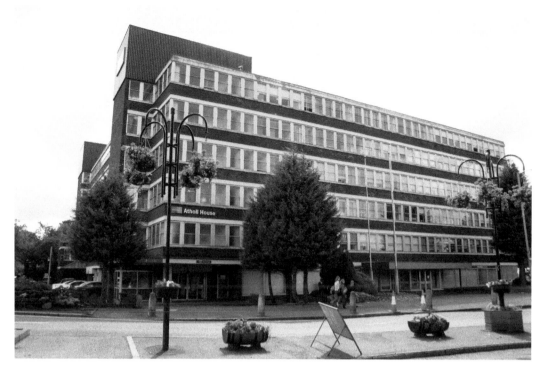

The Dickie Site

Atholl House is the local headquarters of South Lanarkshire Council and previously was the headquarters of the East Kilbride Development Corporation. William Dickie and Sons Ltd manufactured haymaking machines, rick-lifters and pumping windmills, employing over one hundred people.

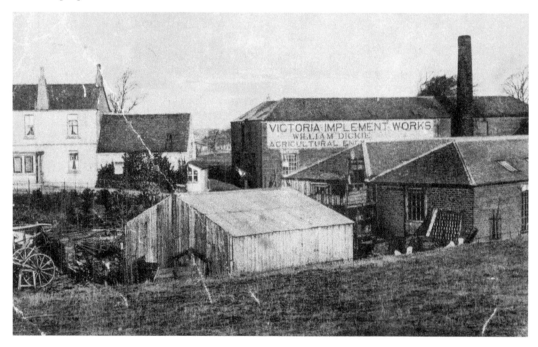

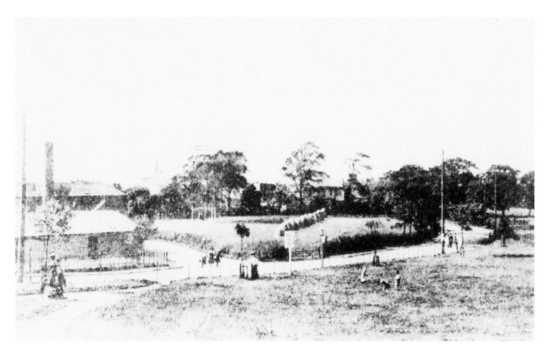

Laigh Common

The chimney on the left is that of William Dickie and Sons Ltd, on the junction of Glebe Street and Avondale Avenue. In the foreground is Laigh Common Park, laid out in 1896. In the older picture, Whitemoss Avenue lies on the right and Atholl House occupies the background.

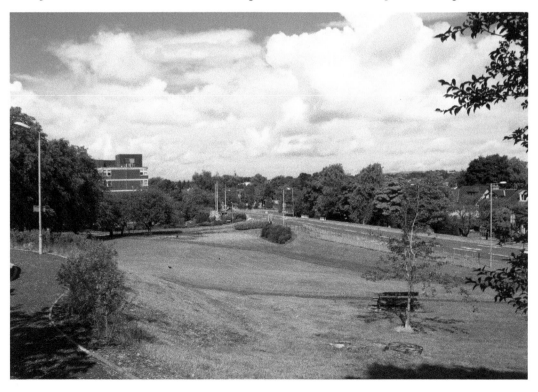

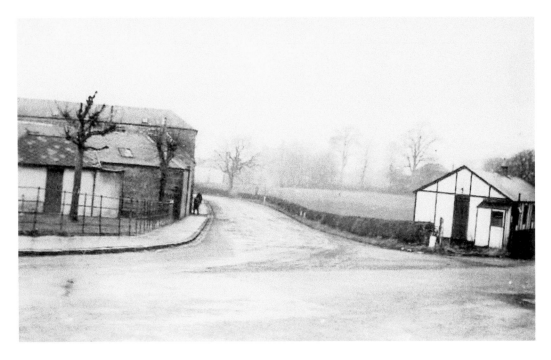

Lantern House

The building on the right, opposite Dickie's, is Lantern House, the home of the local Girl Guide Company until it was adapted as a public library in the early 1950s. Glebe Street sits at right angles to the Strathaven Road (Avondale Avenue) and in the trees to the right is Wellbeck House (Old Manse).

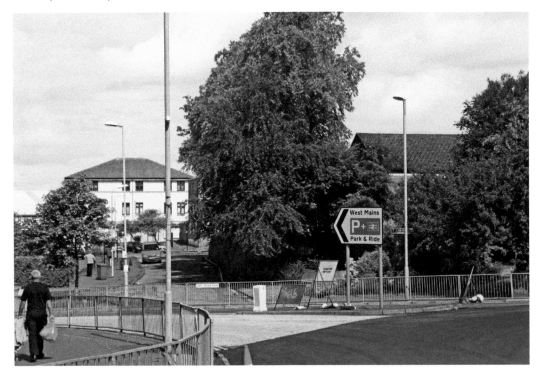

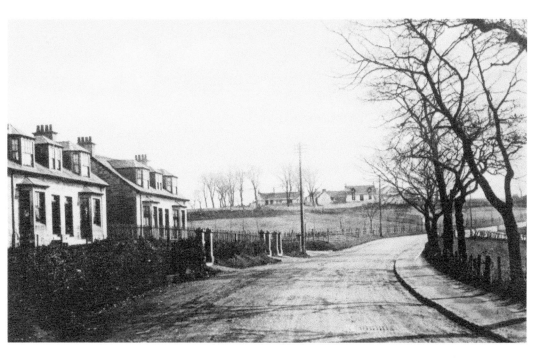

Strathaven Road

Strathaven Road is now Avondale Avenue and the black and white picture of 1918 depicts the Laigh Common Park in the centre. In the background is Platthorn Farm. The modern view shows the Priestknowe roundabout and Glebe Street.

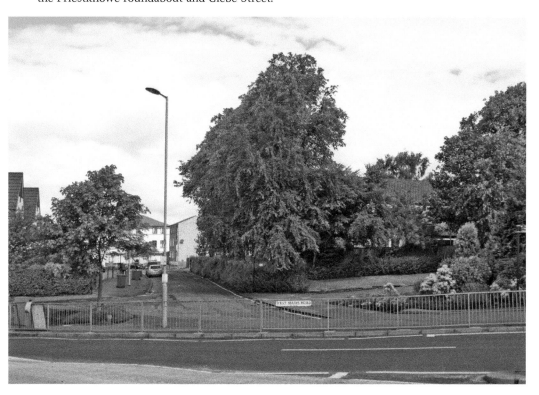

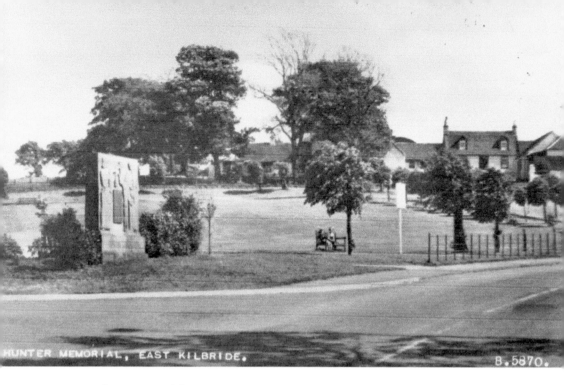

Hunter Brothers Memorial

The brothers William and John Hunter were honoured by a memorial sculpted by Benno Schotz and placed in the Laigh Common Park in 1937. With the development of the New Town, the memorial was moved across the road in 1958.

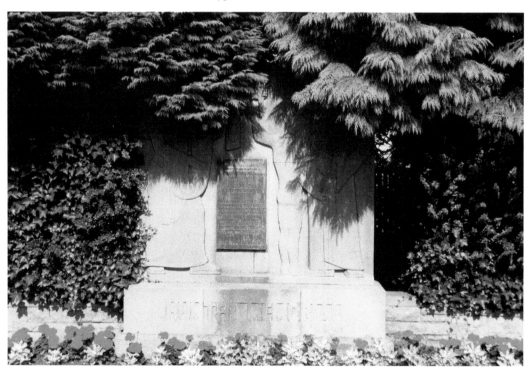

Saint Bride's Church

Opened in August 1964, St Bride's church moved from Glebe Street to Whitemoss Avenue. The building received a number of architectural awards. However, the bell-tower or campanile became unsafe and was demolished in the 1980s. The two views show the church before and after this demolition.

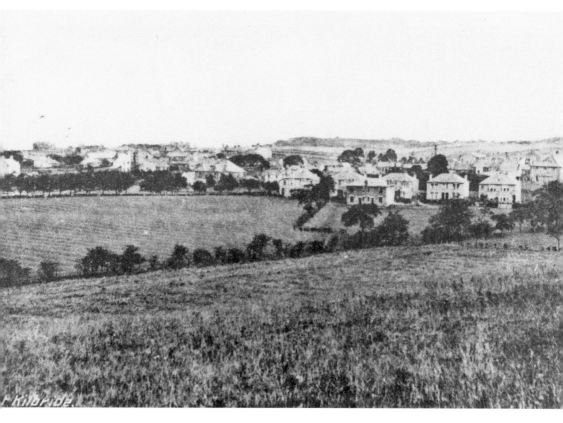

Town Centre Park

The 1912 black and white picture depicts Brouster Hill and the old village. The area is now part of the Town Centre Park. The curved area served as a paddling pool until it was abandoned in the 1970s.

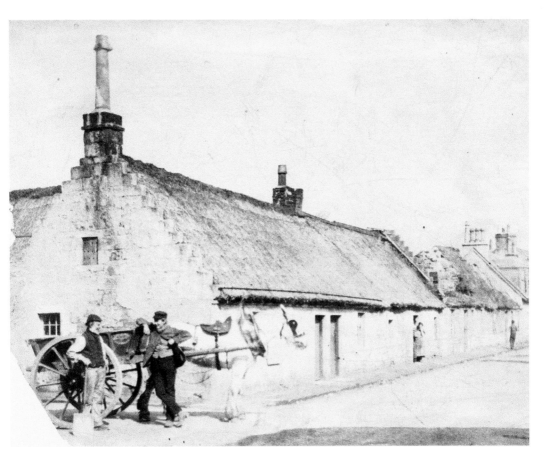

Maxwell Drive

The 1885 view of Maxwellton Avenue (now Maxwell Drive) shows two local farmers deep in conversation. Major changes have been effected in the modern village where new and old buildings are merged.

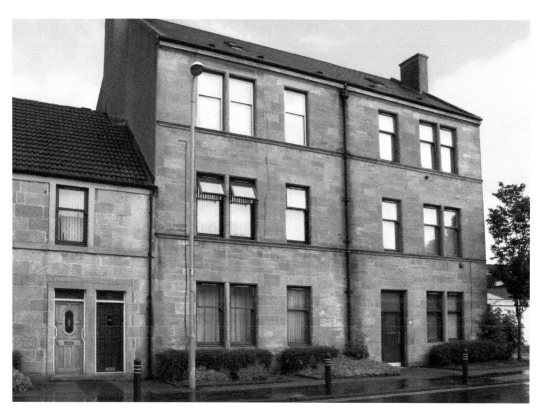

Kate Dalrymple's Cottage

At the right of this picture of Maxwellton Road (now Maxwell Drive) is the Cross Roads Inn (now the Village Inn) and immediately beyond, from 1913, was the village post office, until the early days of the New Town. The milkman is none other than the ubiquitous Jimmy Scott.

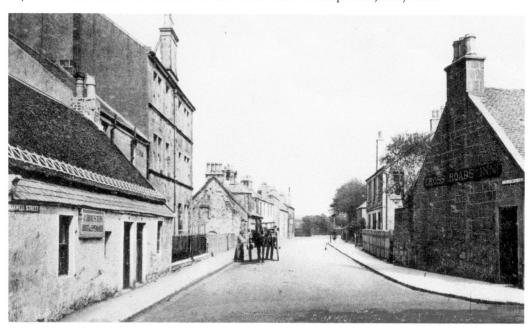

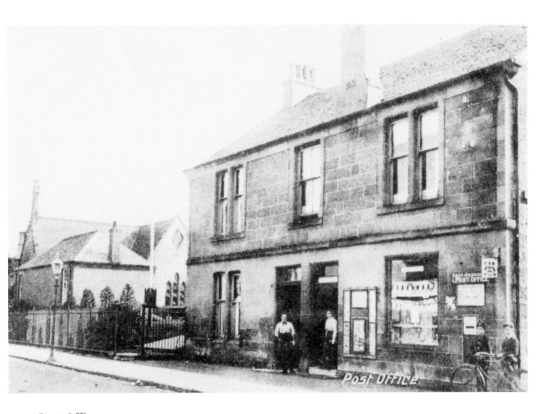

Post Office

Beside the village post office in Maxwell Drive are two boys with a bicycle; one is a uniformed telegraph boy. Beyond is the East Kilbride Bowling Club, founded in 1872. The coloured view shows the modern Village Inn and the view east to Maxwellton Village.

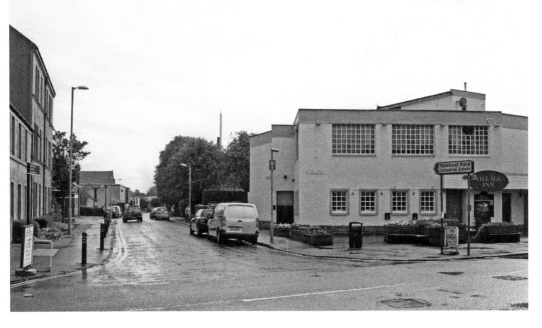

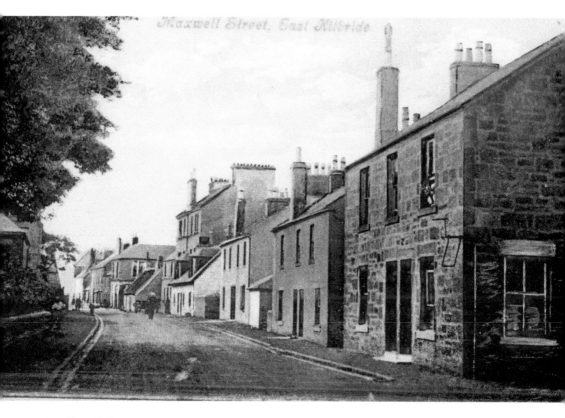

Bowling Club

The north side of Maxwell Drive is pictured in 1910. In the coloured picture the local Bowling Club is seen at play. The building on the far right is the East Kilbride Baptist church, which, in 1959, purchased the church from the Moncreiff Church of Scotland.

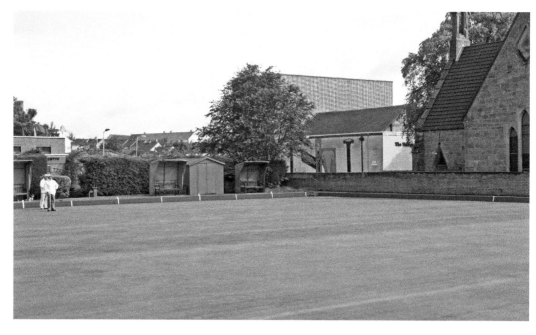

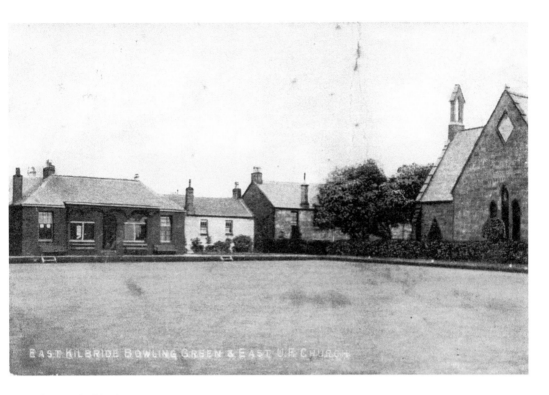

EAST KILBRIDE BOWLING GREEN & EAST U.P. CHURCH

Poetry in Motion

East Kilbride Bowling Club was founded with 30 members in 1872. The influx of new families after the opening of the Caledonian Railway was a strong factor in the establishment of sporting organisations and the Masonic Lodge.

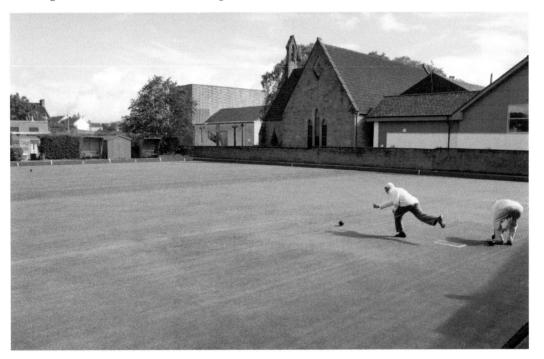

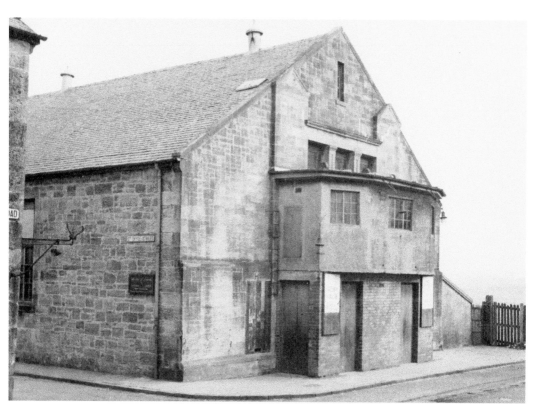

Public Hall

The public hall opened in 1881 and for many years served the village as a hall and cinema. In 1978 the hall was transformed into the village theatre. The metal figures in the foreground are one of many public works of art in the town.

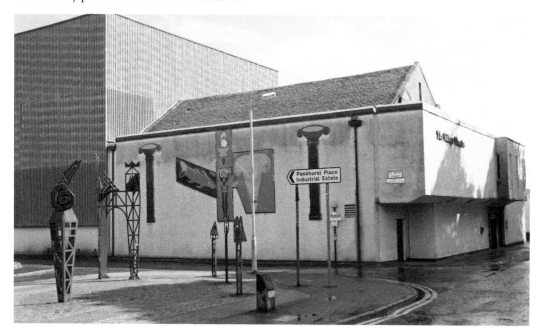

Parkview

Lying to the west of the Show Park, Parkview contained the village gasworks (third building from the right). Modern Parkview is an industrial complex containing a number of small factory units.

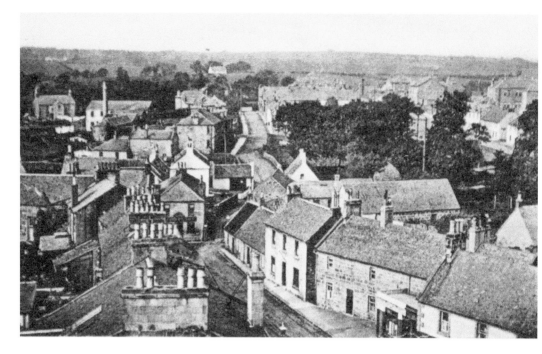

Steeple View North

The view from the parish church steeple in 1911 portrays the vista to the north via Montgomery and Parkhall Streets. In the modern photograph the major changes, particularly in the centre on Parkhall Street, are apparent.

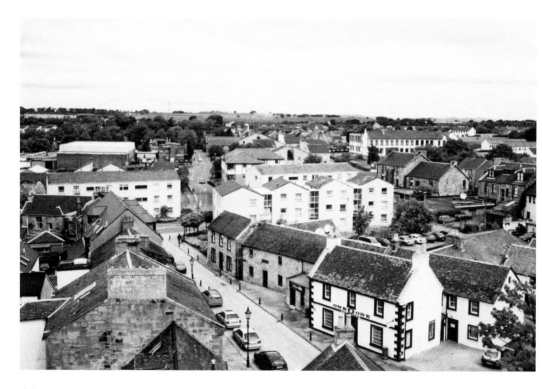

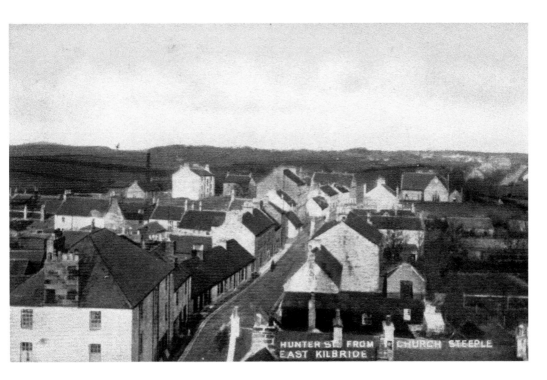

Steeple View East

The view east from the church steeple over the hundred years between the two photographs shows significant changes in the near left. Hunter Street merges with Maxwell Drive at the Cross Roads. On the modern image the massing of the New Town housing can be observed.

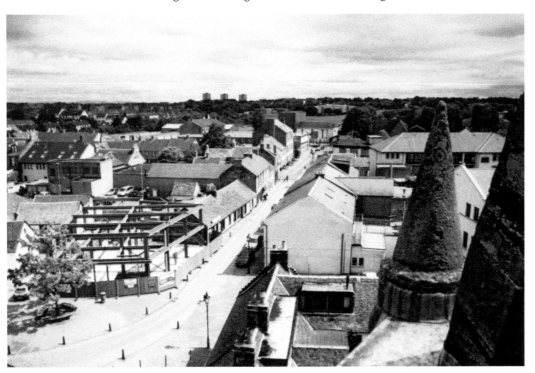

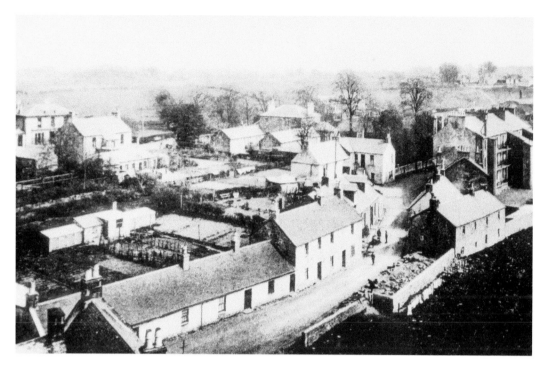

Steeple View South

The changes to the view south from the steeple over the hundred year gap are extensive. Most of Glebe Street has been replaced and on the right horizon stands the local headquarters of South Lanarkshire Council, in front of which is the Priestknowe roundabout.

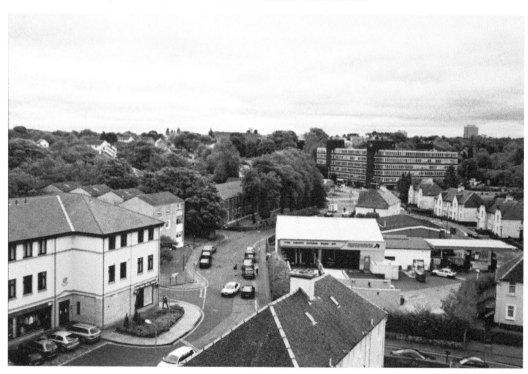

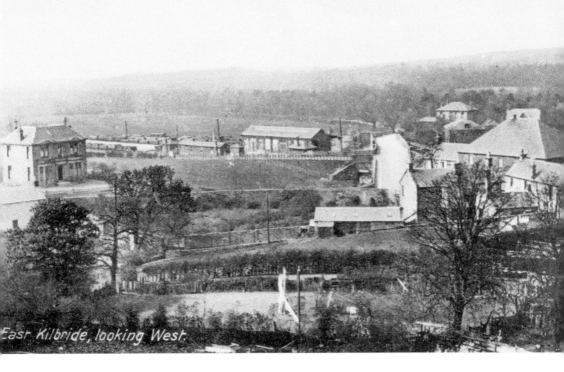

East Kilbride, looking West.

Steeple View West
The black and white picture of 1911 depicts the old West Kirk Manse on the upper left and the railway station adjacent. In the modern photograph, Lindsay House is in the near right and beyond is housing in East and West Mains.

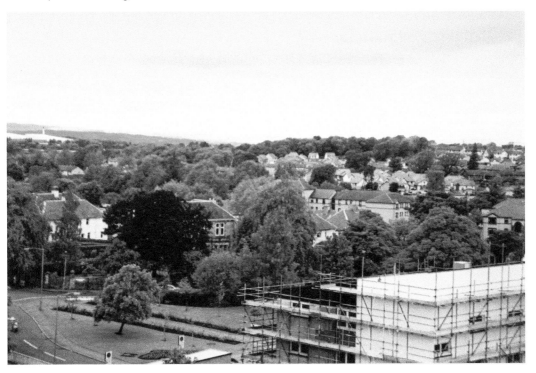

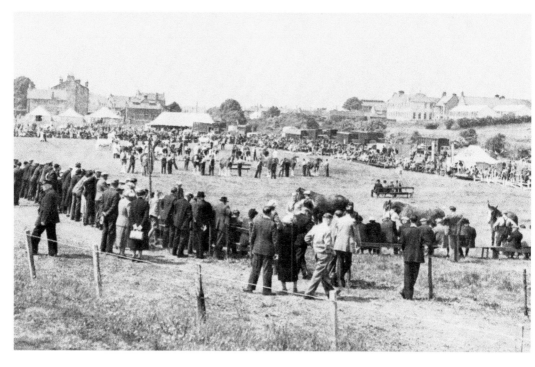

Cattle Show

The East Kilbride Cattle Show was founded in 1772 and was first held in the Show Park (pictured) in 1838. The black and white image depicts the show of 1953, during the first years of the New Town. In the 2009 show several highland cattle are paraded.

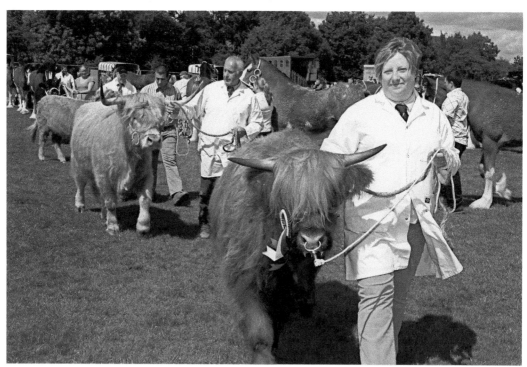

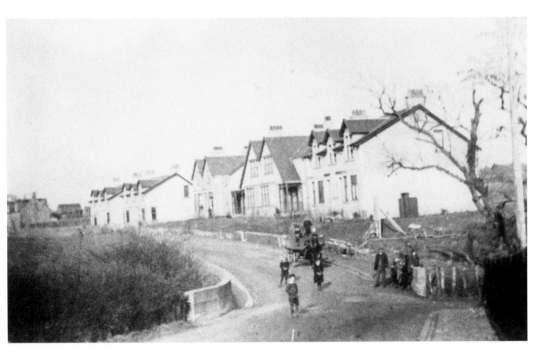

The Sanny Brig

The Sanny Brig on the old Maxwellton Road was the boundary of Maxwellton village, which, until the early nineteenth century, led an independent life. The houses in the modern photograph were built by the SCWS in 1912.

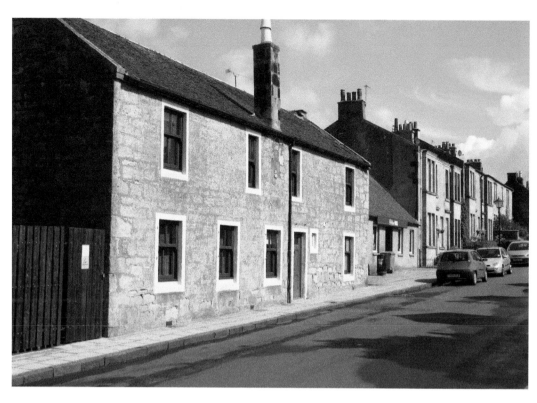

Maxwellton to the East

Maxwellton has been a conservation area since the mid 1960s. The modern image gives a good impression of this attractive weaving village which possessed its own school, endowed by Sir William Maxwell, until 1911.

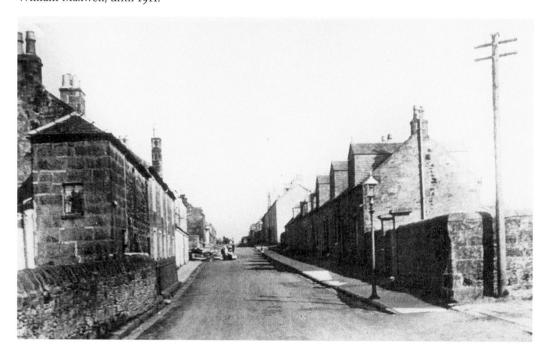

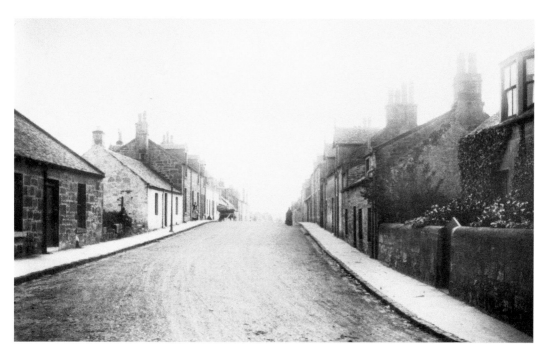

Top of the Town

When mechanisation overtook the weaving industry in around 1850, many weavers were impoverished. In their place came mining families from Blantyre. The village developed a strong sense of community thereafter.

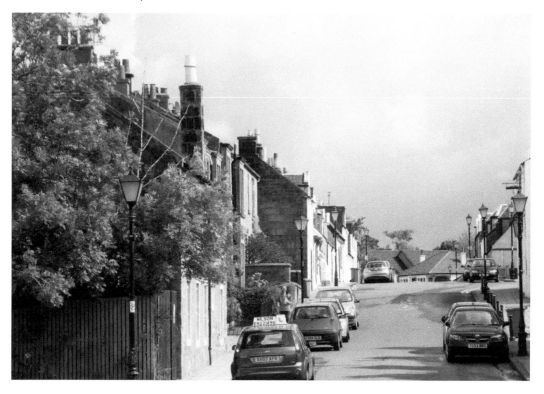

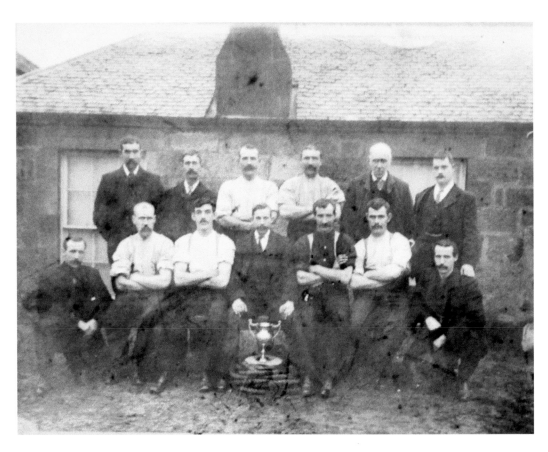

Maxwellton Endowed School

The thirteen men in this image from 1902 comprise the local miners' quoiting team. They are pictured behind the school. In the colour photograph the houses on the far right were built for the head teacher and staff.

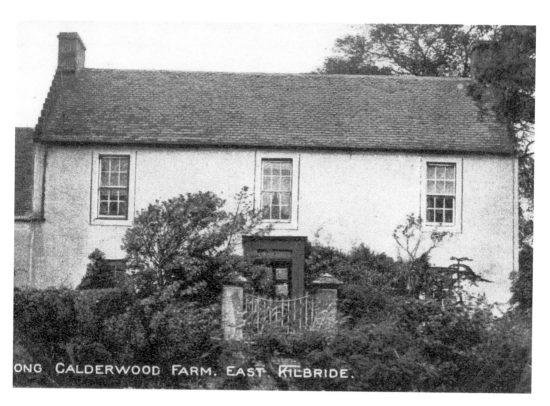

ONG CALDERWOOD FARM. EAST KILBRIDE.

Hunter House

Long Calderwood Farm was built by John Hunter Senior in 1720. Of his ten children, William became a famous obstetrician and donated his collections of coins and paintings to Glasgow University. John became known as the father of modern British surgery. The building is now a museum.

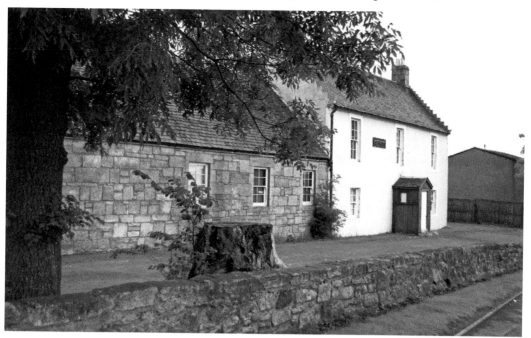

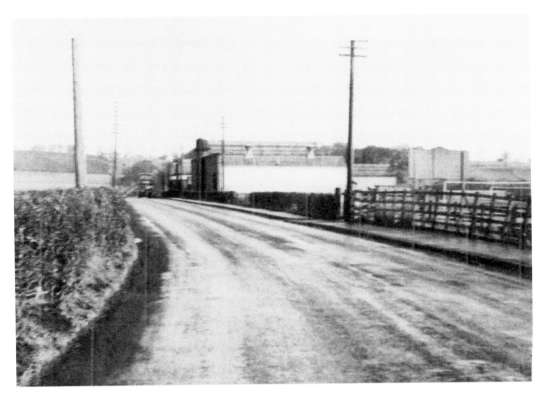

Mavor and Coulson

Mavor's set up in East Kilbride in 1927 and soon became the largest village employer, manufacturing a range of coal cutting machinery. Since 1988 the factory has been used for other purposes with a much reduced labour force.

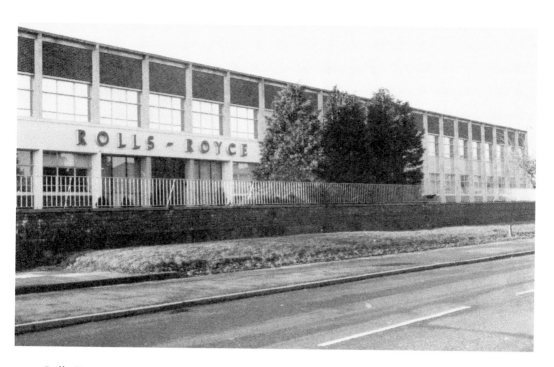

Rolls-Royce

A factory for the manufacture and repair of aero engines was established in 1953 and became the town's largest employer. This aerial image shows the modern factory. Upper centre in the picture is Mains Loch, and to the left is Stewartfield.

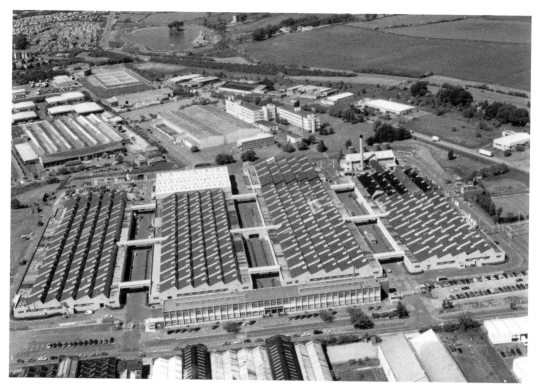

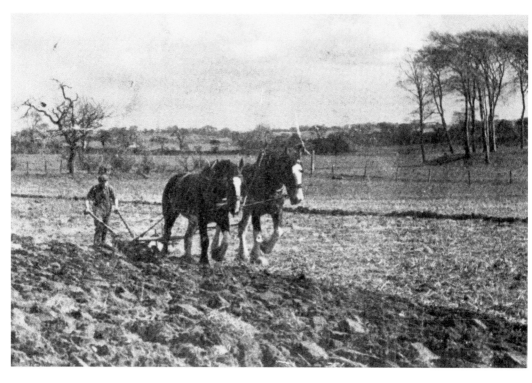

Mains Loch

Feg Wallace of High Mains Farm is seen ploughing the fields near to the artificial island. The loch, flooded in 1555, was drained in 1770. In 1994 the area was developed as the James Hamilton Heritage Park, offering a range of water sports.

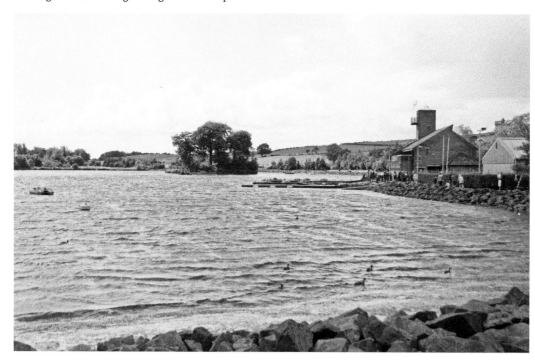

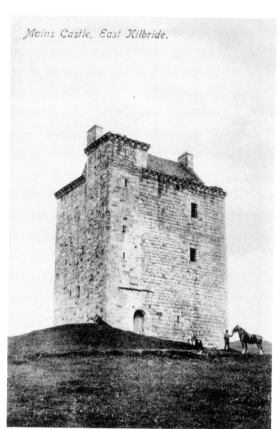

Mains Castle, East Kilbride.

Mains Castle

Mains Castle was built *c.* 1450 by the Lindsays of Dunrod. John Lindsay became Baron of Kilbride in 1382 for services to the Royal Bruce family. The castle was restored to its former glory by Mike Rowan in 1978.

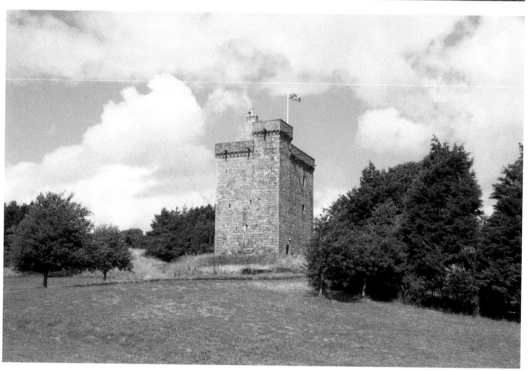

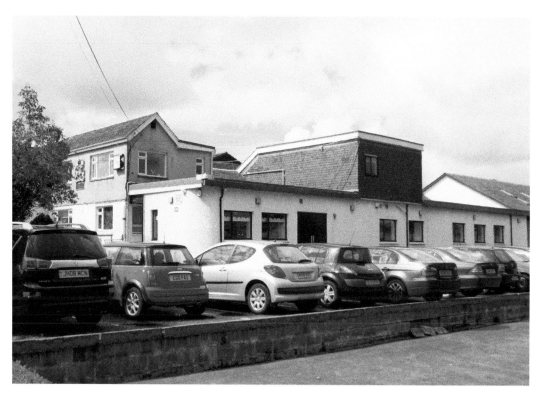

Robert Wiseman Dairies

Nerston lies a mile or so north of East Kilbride and is the home to the Wiseman family, owners of one of the largest milk producers in the United Kingdom. Their headquarters are depicted in the colour image. The black and white photograph shows Nerston, *c.* 1930.

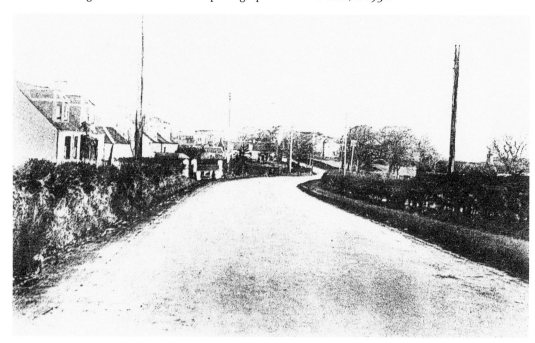

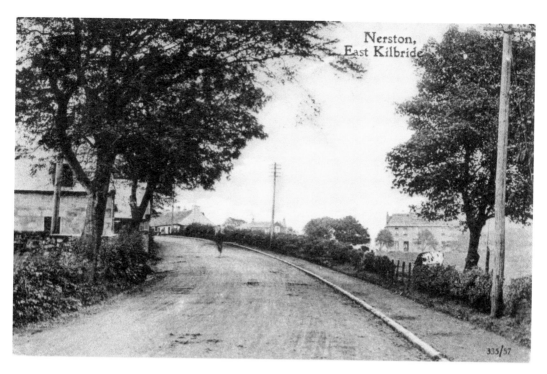

Nerston Looking North

Although Nerston has been developed in recent years, the original road pattern is still extant. Among the buildings on the left was the old blacksmith's, and in the older image the local authority buildings for children with special needs can be observed.

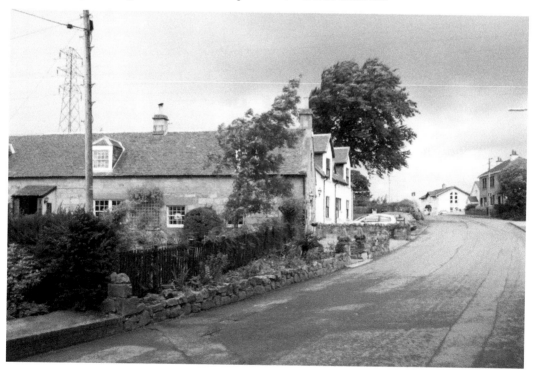

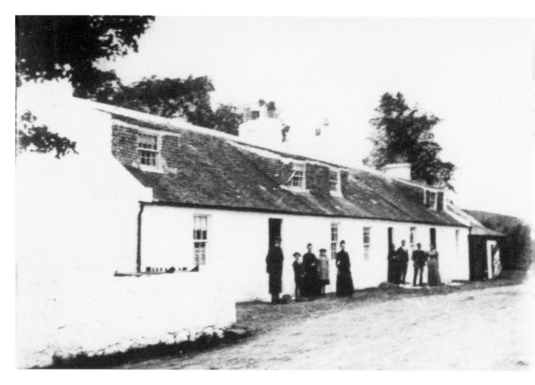

Sparrow's Castle

Nerston is a contraction of a north-east town. The old photograph of 1902 depicts the Row, and on the right is the steam dairy. The Row was replaced by a set of two-storey houses called Sparrow's Castle, which in turn gave way to these modern residences.

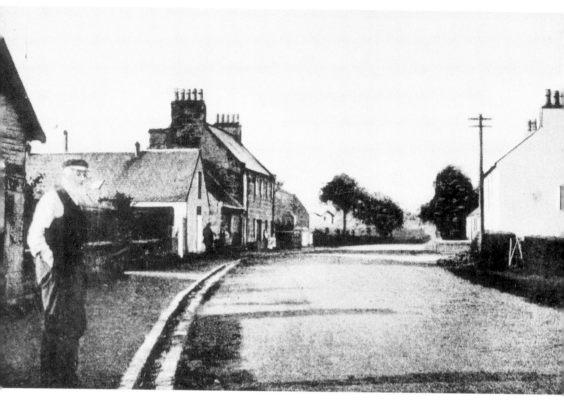

Jackton

Jackton, to the west of East Kilbride, lies on the road to Eaglesham. The black and white picture of 1918 portrays the Steel's contracting business, and the colour photograph shows the blacksmith, the Struthers house.

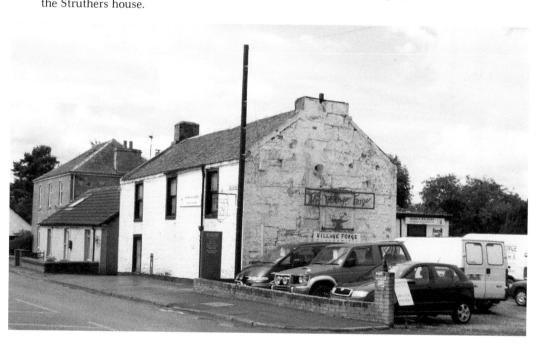

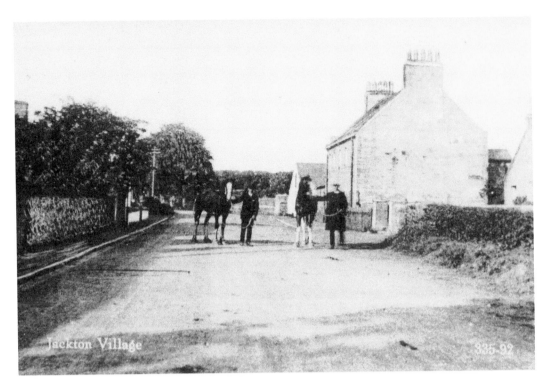

The Jackton Clydesdales

The Steel family have long been famous for breeding and showing Clydesdale horses. Jimmy Steel has carried this tradition into the twenty-first century with frequent appearances at the Royal Highland Show.

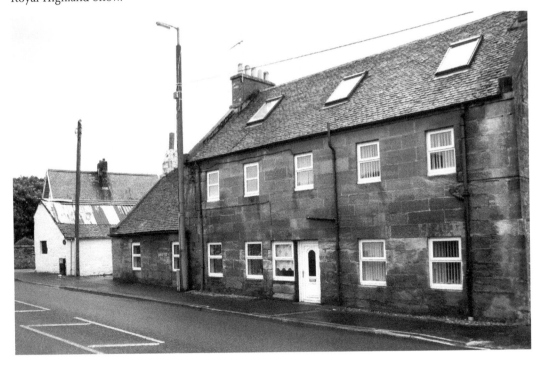

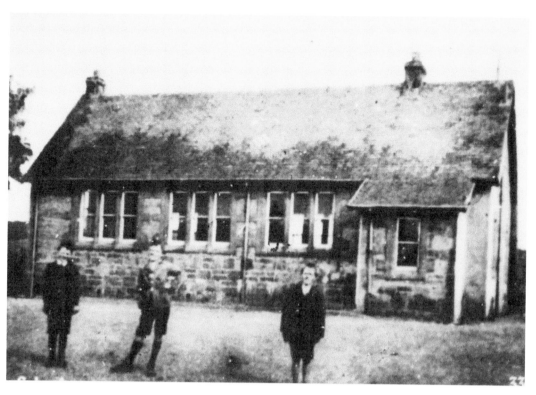

Jackton School

Jackton's first school was opened in 1840 and the next school (pictured) was established in 1876. A schoolmaster's house was also built (colour photograph). The school closed in 1988 and the building was sold.

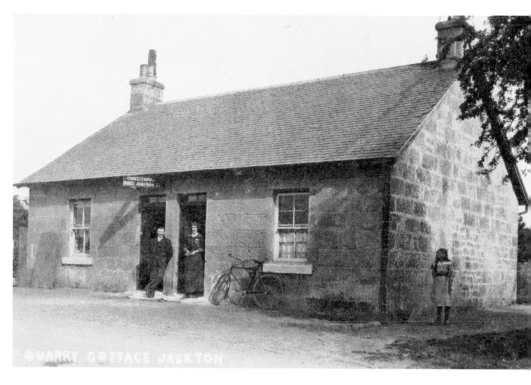

Bogton Cottage

Quarry Cottage at Jackton served as the local shop for Jackton and the district. One disadvantage was its lack of post office facilities. The cottage is now much extended and is used by the owners of R. L. Cars.

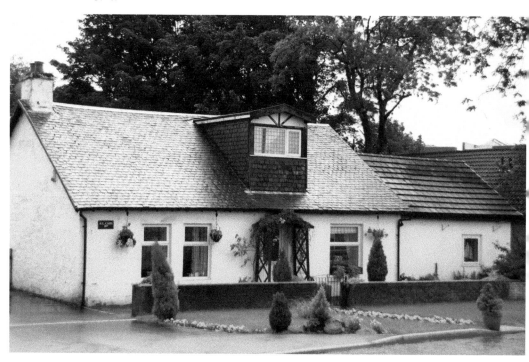

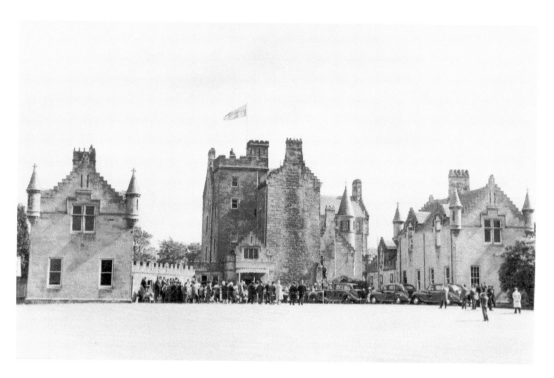

Torrance Castle

Home of the Stuart family since 1620, Torrance Castle became the headquarters of East Kilbride Development Corporation in 1947. The black and white image depicts a visit by Her Majesty the Queen and Prince Philip on 4 July 1962. The east wing was gutted by a fire in 1965 and demolished.

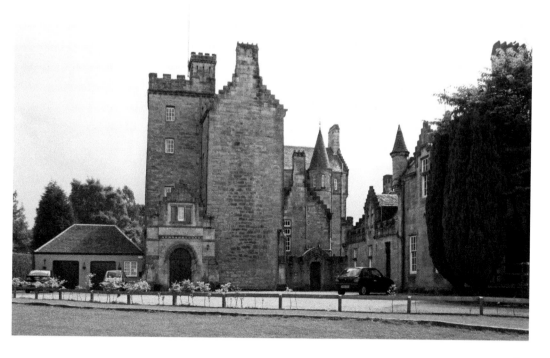

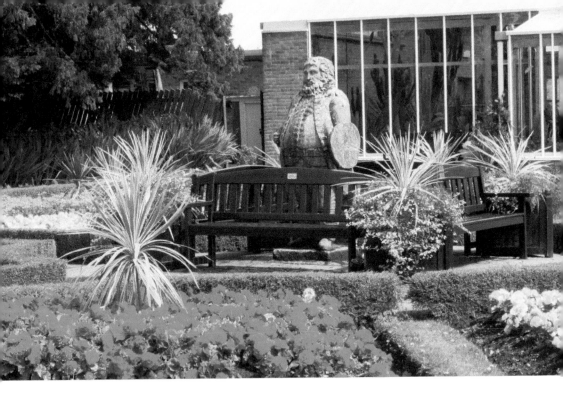

Falstaff

Falstaff, that larger than life Shakespearean creation, was transported to Torrance Castle in the 1920s. Here he stands beside Winnie Browning. In 1982 he became the centrepiece of a magnificent floral display in the Conservatory Gardens.

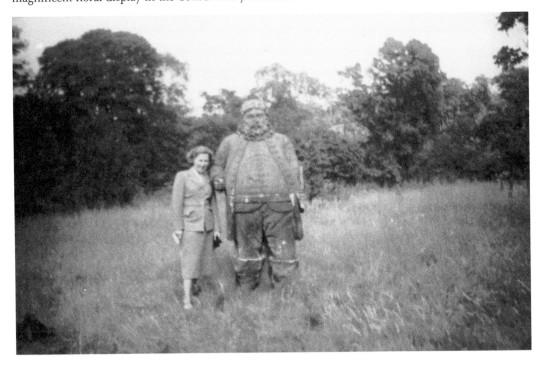

Newhousemill
In the older picture the cotton spinning mill can be seen on the far right. The cottages were built for the mill workers and were also used for employees of the Torrance estate.

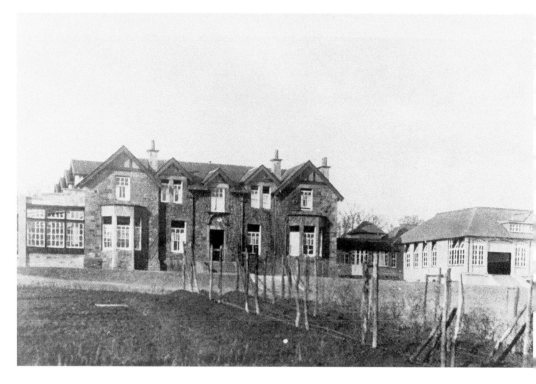

Hairmyres Hospital

Opened in 1904 as an Inebriate Home for Women (pictured), the hospital became an important TB sanatorium in 1919. George Orwell spent 7 months here as a patient in 1947/48, while writing his satirical novel *Nineteen Eighty-Four*. A new hospital with 451 beds was built on the site and opened in September 2001.

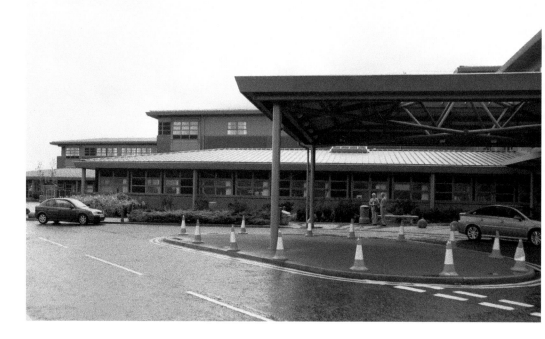

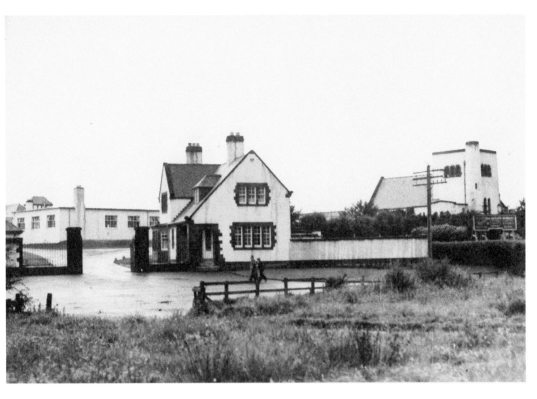

Philipshill Hospital

Opened in 1929 and closed in 1992, Philipshill Hospital was an annexe of the Victoria Infirmary. In its later years it became an orthopaedic hospital specialising in spinal injuries.

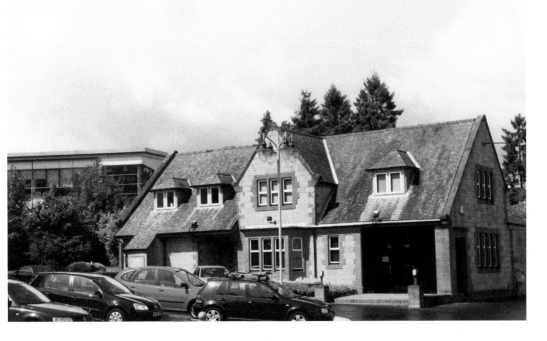

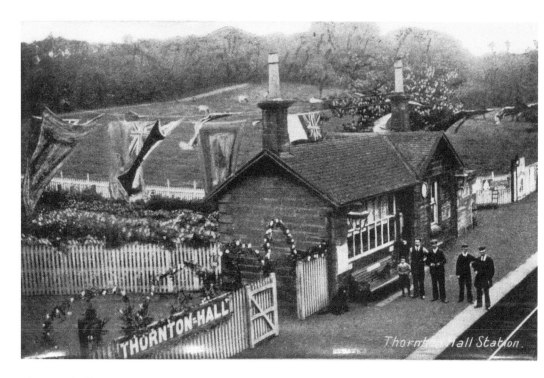

Thorntonhall

The station opened in 1868 when the Caledonian Railway extended the track from Busby to East Kilbride. The area has proved attractive to commuters and a considerable volume of upmarket housing has been purchased. In its heyday the station gained an enviable reputation for its floral displays.

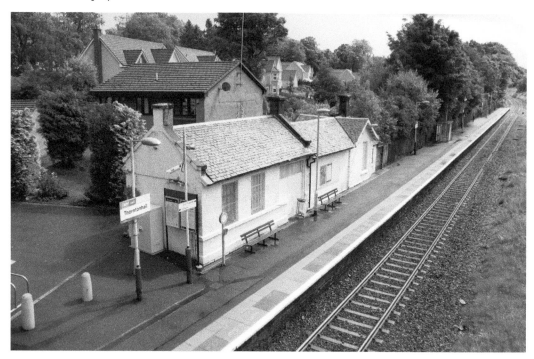

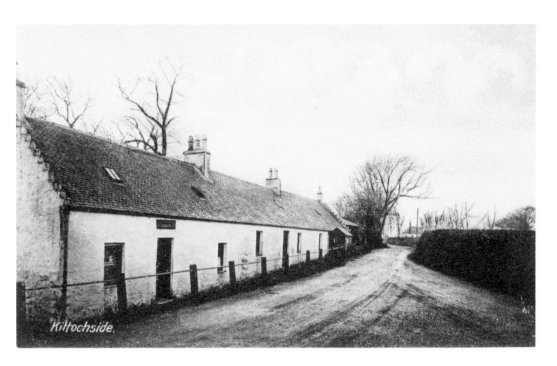

Kittochside

Kittochside lies three miles west of East Kilbride; the area has escaped any urban development. The National Museum for Rural Life is situated in the hamlet. The row of cottages is little changed with the exception of the closure of the shop in the old photograph.

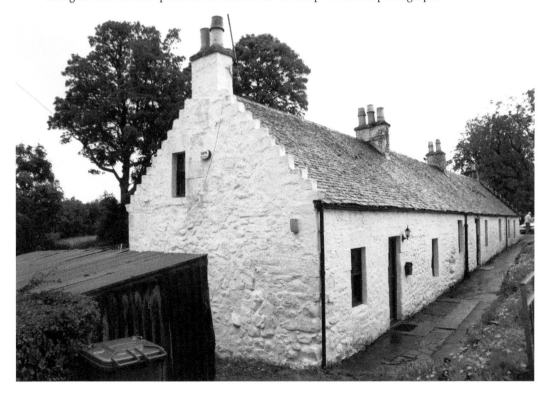

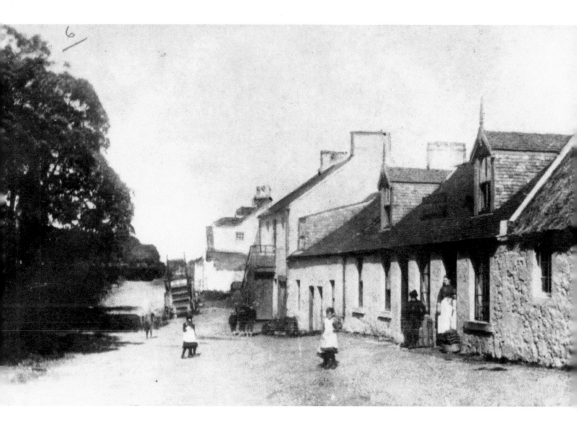

Auldhouse

Auldhouse lies on the old road south and is largely unchanged. The Auldhouse Arms on the near right is a popular hostelry. The hamlet was an overnight stop for the drovers who herded black cattle to England.

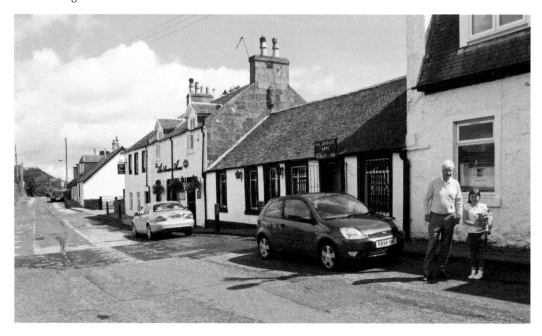

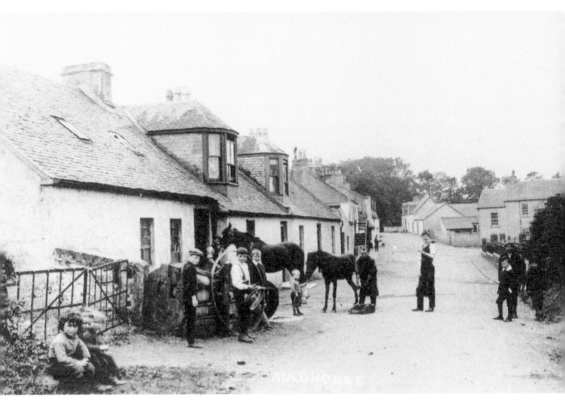

Looking West

At the east end of Auldhouse was the blacksmith's and in older times a second tavern was there as well. Auldhouse was highly dependent on its farming industry and milk production was the most important farm activity.

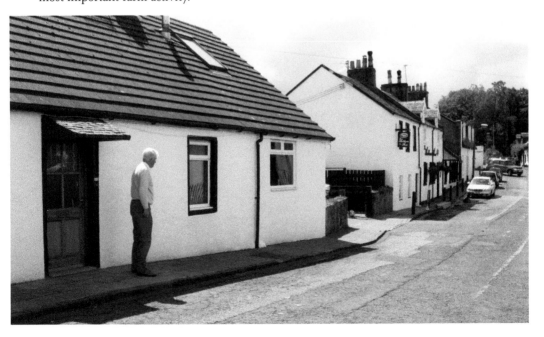

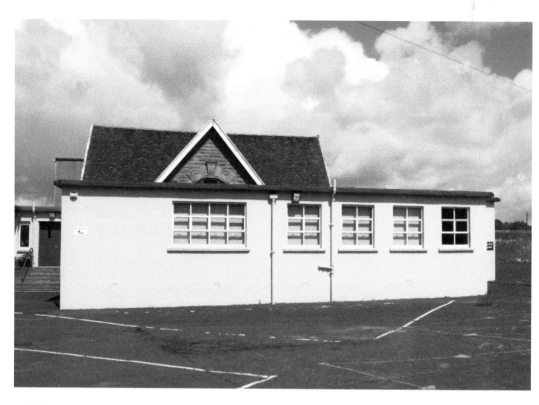

Auldhouse School

The area had a school as far back as 1720. The present building (in the coloured image) was constructed in 1900; a comparison of the two photographs clearly shows the extensions that have been made.

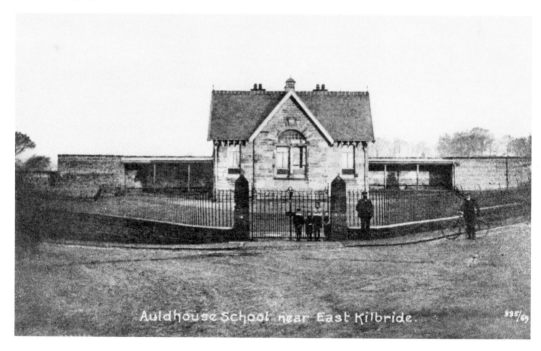

Auldhouse School near East Kilbride.